THEN & NOW®

MILFORD

OPPOSITE: Liberty Rock, once known as Hog Rock due to its similar shape, sits on the north side of the Boston Post Road about one mile east of the Washington bridge. This site served as a signal station for the Milford Patriots during the Revolutionary War. (Author's collection.)

MILFORD

Michael F. Clark

This book is dedicated to my wife, Missy, who is the love of my life; and to my three beautiful grandchildren: Spencer, Zoe, and Hudson.

Copyright © 2016 by Michael F. Clark
ISBN 978-1-4671-2433-1

Library of Congress Control Number: 2016949272

Published by Arcadia Publishing
Charleston, South Carolina

Printed in the United States of America

Then and Now is a registered trademark and is used under license from Salamander Books Limited

For all general information, please contact Arcadia Publishing:
Telephone 843-853-2070
Fax 843-853-0044
E-mail sales@arcadiapublishing.com
For customer service and orders:
Toll-Free 1-888-313-2665

Visit us on the Internet at www.arcadiapublishing.com

On the Front Cover: Pictured in 1907 and 2016 are the waterfalls at the Memorial Bridge. See page 57 for more information. (Both, courtesy of New Haven Museum.)

On the Back Cover: In 1914, residents are seen at the town green celebrating Milford's 275th anniversary. (Courtesy of the Moger Collection.)

CONTENTS

ACKNOWLEDGMENTS

I wouldn't have been able to put this book together without the help of these fine people and organizations. Thanks to the members of the Milford and Devon Facebook pages, who provided so much inspiration; Katherine Krauss Murphy, who suggested writing this book, provided information and pictures of Woodmont, and also helped with the editing; Daniel E. and Roma C. Moger (DRM) photo collection; the New Haven Museum (NHM); the Milford Historical Society (MHS); Lasse's Restaurant (LR); Milford Yacht Club (MYC); Connecticut Post Mall (CPM); Nancy Hermann (NH); Eleanor R. Benefico (ERB); Margaret G. Giles (MGG); Moe Knox (MK); James Stewart (JS); Richard Smith Jr. (RS); Thomas F. Maher IV (TFM); Connie Pascarella (CP); James Simone (JS); David Gregory (DG); Stephanie Gloria Sullo (SGS); James Chedister (JC); Rev. Karl Duetzmann (RKD); Rev. Kenneth Fellenbaum (RKF); and Dick Platt (DP) and Tim Chaucer (TC), not only for their contributions, but also for their tireless efforts in going above and beyond to save Milford's historic landmarks. All of the Now photographs that appear are from the author's collection.

Unless otherwise stated, all images are from the author's collection.

INTRODUCTION

Before the early settlers arrived on this land, the Paugussett Nation inhabited much of western Connecticut from West Haven to Norwalk and as far north as a canoe was able to take them. On the land that is now called Milford, the Native American members of the tribe were known as the Wepawaugs and were also later referred to as the Milford Indians. The language spoken by these local natives was known as Algonkian. Four of their many villages were located at the Wepawaug River (near where the First United Church of Christ was later built), Indian Point (today's Gulf Beach), the Turkey Hill area, and Milford Point, which the Indians called "Poconoc." There, oyster shell beds, some up to seven feet deep, were found at the mouth of the Housatonic River. They called this river "Ousatonic," meaning "place beyond the mountains."

Ansantawae was the sachem, a paramount leader, of not only the Paugussett tribe but also of the Quinnipiac tribe, and claimed the territory from New Haven to Madison. Ansantawae had two wigwams in Milford: one on the Wepawaug River, just north of the Memorial Bridge, and a larger one, used during the summer months, on Charles Island, called "Paquahaug" by the Wepawaugs. Today, you can see the depiction of the Indian leader Ansantawae chiseled in granite above the door on the Memorial Tower, as well as on the exterior northern side of the Memorial Bridge.

During the reign of King Charles I in England, large numbers of people were fleeing the English church for their nonconformity, migrating to New England in search of better lives. In the year 1639, the lives of the Wepawaugs would be changed forever when a congregation of English Puritans, led by Rev. Peter Prudden, settled here and formed an independent colony, referring to this new land as "Wepowage." When Ansantawae realized that the visitors wanted to purchase his land, he held council with his tribes and came to the conclusion that the new settlers would be beneficial to them by providing protection against the Mohawk tribe, which lived farther to the north and frequently attacked the Wepawaugs by sweeping down along the coastline. Ansantawae's decision was to sell part of his land to the settlers and move to Indian Point.

On November 24, 1640, the settlers voted to change the name of their new land from "Wepowage" to Milford. Milford joined the New Haven Colony in 1643 and the Connecticut Colony in 1664. Ansantawae eventually sold off the remainder of the land, and the tribes slowly disappeared, as the population of settlers began to explode in number. Ansantawae was said to be a great chieftain who was neither inactive nor lazy. He loved to fish and work among his people. Ansantawae, who lived to be an old man, was said to have served his people faithfully.

Now, more than 375 years later, the city of Milford is bustling with activity. It is the sixth oldest city in Connecticut with the longest shoreline in the state (17 miles) and the second longest town green in New England.

I grew up in the Devon section of Milford, from the late 1960s to the early 1980s, when kids were always outside playing into the early evening. There must have been 50 kids on Spring Street where I grew up. There were no cell phones, video games, nor iPads. For us, a treat would be walking over the Devon Bridge to play a lonely pinball machine in a Laundromat at the Dock Shopping Center or getting a quarter from our parents to buy a bag of penny candy at the Butterfly Net Soda Shop on the corner of Naugatuck and Bridgeport Avenue. We played Wiffle ball in the neighbor's yard and built little ramps on the street, thinking we were Evel Knievel on our Schwinn bicycles. We would buy a pack of Topps baseball cards, and separate the teams with rubber bands, storing them in a shoe box. We'd climb the arches under the Devon Bridge, and ride our bicycles to Wanda's Sugar Shack on New Haven Avenue, all the way on the other end of town.

A family dinner night out would be burgers, long dogs with the works, onion rings, fries, and shakes at Cricket's in Stratford, pizza at the Apizza Center on the Boston Post Road, or our favorite, a bucket of fish and chips at Bel-Air Seafood on Bridgeport Avenue in Devon.

I was lucky enough to have worked at some of Milford's great landmarks when I was a kid; Harrison's Hardware was my favorite, when individual service was still available. I'll never forget oiling those creaky wooden floors. Cleaning the grounds and repairing speakers at the Milford Drive-In was interesting; I ate a lot of stale popcorn those mornings. I worked for the CETA (Comprehensive Employment and Training Act) program at Central Grammar School one summer, mopping and waxing floors and going to Donahoe's on River Street for a cheeseburger, cherry Coke, and a bag of greasy fries for lunch. I wouldn't trade those memories for anything.

As a kid, and even as a young adult, I never thought much about Milford's history and really didn't start being aware of it until one day, when I was looking for some old Milford photographs to hang in my house. I was so taken aback when I came across pictures of Devon 100 years ago, the bucket cop, the Memorial Bridge, Walnut Beach, and landmarks around the town green. I became hooked. I started to collect postcards, newspapers, magazines, and prints and illustrations of Milford. Milford has a rich history—something that should be cherished and not taken for granted. I am proud to have grown up in Milford and to have called it my home.

WORSHIP AND EDUCATION

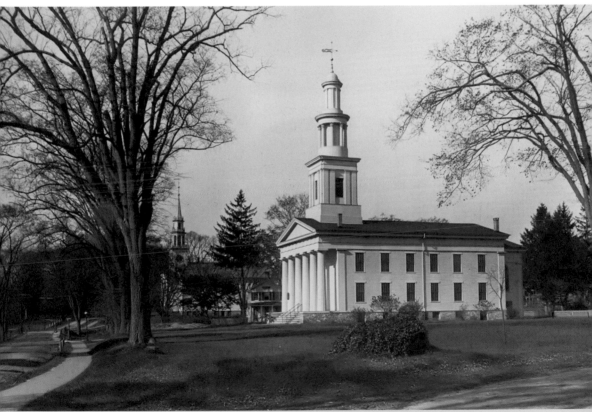

Looking west toward West Main Street on October 31, 1907, one sees the Plymouth Church in the foreground, which was razed in 1951 and replaced with the current Plymouth building, and the First United Church of Christ in the background. Between the two churches over the Wepawaug River is the Meetinghouse Bridge, Milford's very first bridge, built in 1640. Most of the early settlers to Milford fled England to avoid religious persecution. From 1707 to 1719, the Rev. Samuel Andrew, pastor of the First United Church of Christ, was also the first rector pro tempore of Yale College. During those 12 years, he provided personal supervision to the Yale senior class in Milford. (NHM.)

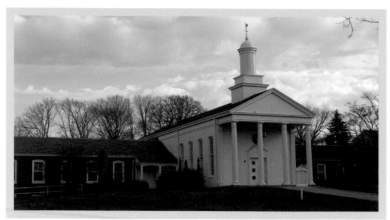

Due to dissension among a minority group of parishioners at the First United Church of Christ, this small group seceded and built a new meetinghouse in 1743. Named the Plymouth Church, it was only yards away from First United Church of Christ but on the other side of the Wepawaug River, shown here. The Rev. Job Prudden, great-grandson of Peter Prudden, one of Milford's original settlers, was Plymouth Church's first steady preacher. In 1926, after 185 years, the two congregations worshipped as one again. For the next 20 years, the Plymouth Church was used for plays and social events until the cost of maintaining the building was too much. It was razed in 1951. The new and current structure is now called the Plymouth Building. (DRM.)

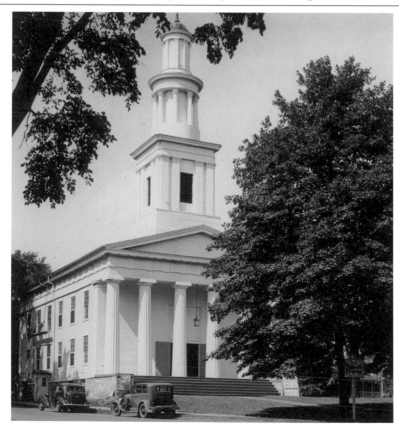

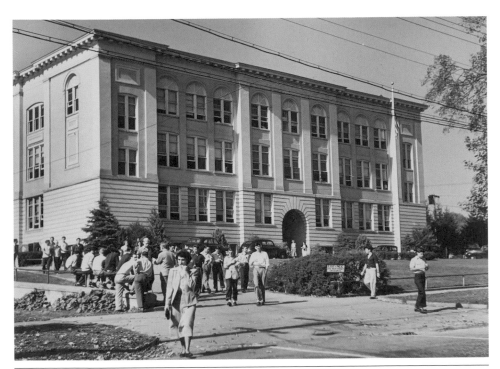

To ease overcrowding of the grade school housed in the town hall, this large 21-room central school, Milford High School, was built in 1908 to accommodate elementary and high school grades. The students loved the new school for the fact that school dances did not have to be held at the town hall anymore and now could be held at the new school's science lecture hall. In 1951, a new 1,350-pupil high school was opened next door at the former site of Clark's Tavern and the Weylister Secretarial School. The old high school, shown here, formally called the Diane Toulson Building, was being used as a storage facility, children's public library, and overflow classrooms for the new Milford High School until 1993, when it became the River Park Apartments for the elderly and disabled. (TC.)

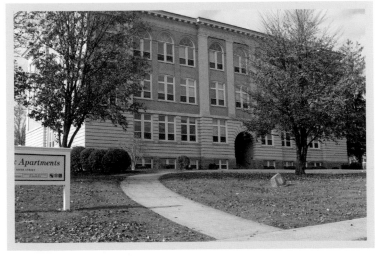

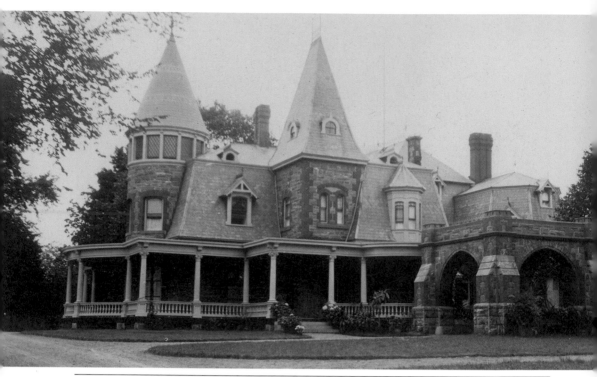

Shown here in 1908, Lauralton Hall was originally called "Island View" and was built in 1864 by Charles Hobby Pond, Milford's third contributing governor to the state of Connecticut. Henry Taylor later purchased the estate and renamed it Lauralton Hall in honor of his daughter Laura, who died at the age of five. Yet again, in 1905, the property was purchased by Rev. Mo. Mary Augustine Claven of the Sisters of Mercy from Meriden, Connecticut, who established a boarding school for girls called the Academy of Our Lady of Mercy. More commonly known as Lauralton Hall, the high school sits on a 30-acre campus, enrolls over 450 students in grades 9 through 12, and was the state's regular season champions in field hockey in 2015 with a record of 10-1. (DRM.)

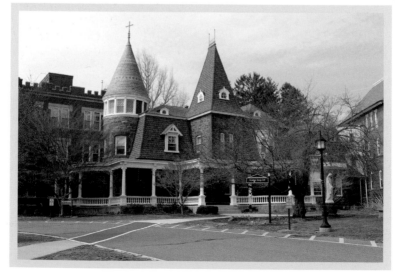

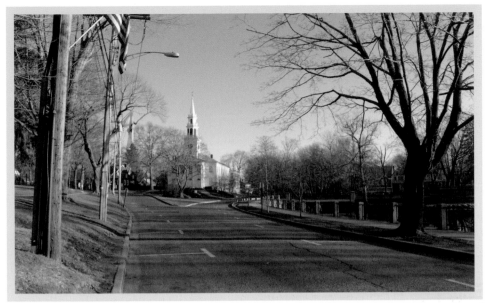

The First United Church of Christ held its first service in New Haven, Connecticut, in 1638 and was organized by the Rev. Peter Prudden. The congregation's first church was constructed in Milford and held services starting in 1641. Until a bell was installed, the congregation was called to worship by the beating of a drum. Due to fear of Indian attacks, when early services took place, a sentinel was stationed in the turret, and guards with muskets were stood at the rear of the church. The church was eventually torn down and replaced with a three-story building in 1728. The church has had only four pastors since 1945, the fourth being Rev. Adam E. Eckhart, who has served as senior pastor since January 7, 2015. (NHM.)

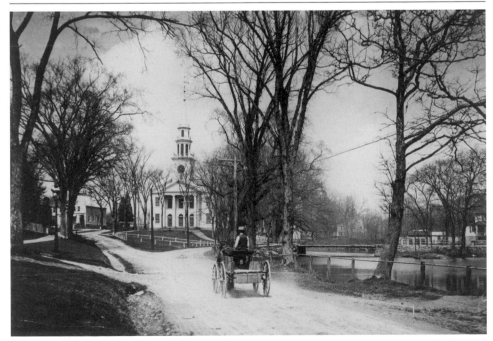

The Mary Taylor Memorial United Methodist Church, shown here in 1920, is located at 168 Broad Street. Area Methodists conducted the first services in a private home in 1789. From 1835 to 1841, services were held at the Bristol shoe shop. A wooden church was dedicated on River Street but had no regular pastor until 1852. On June 25, 1893, a new church was dedicated by the children of Mary Meyer Taylor, who died in 1878 and was the wife of Henry Augustus Taylor. The church still provides services, Sunday school, and a wealth of other services for the community. Mary and Henry Taylor's daughter Laura can be seen in a stained-glass image at the church. (Both, author's collection.)

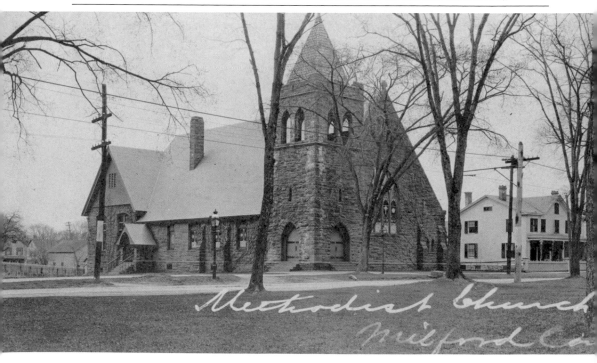

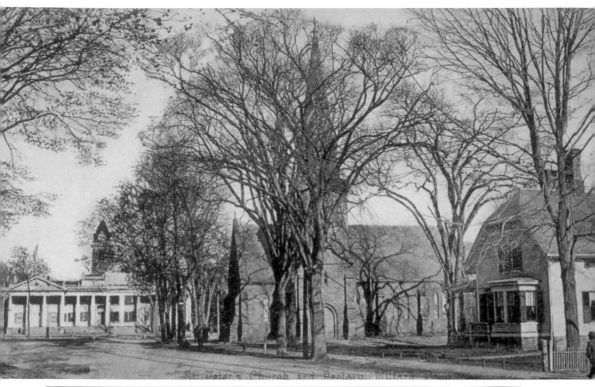

The original name of Milford's St. Peter's Episcopal Church was St. George's, in honor of St. George Talbot, who was the principal financial donor; 28 years after Episcopal services were first conducted in Milford by English missionaries. The original church was constructed of wood in 1769, and pews were not added until 1775. The cornerstone of the current church was laid in 1849, and the building was completed in 1851, with some of the wood used having been salvaged from the old church. Services were scheduled on June 29, 1851, during the feast of St. Peter. During the dedication, the name was changed from St. George's to St. Peter's. The Victorian Gothic design was built with brownstone brought from the quarries in Portland, Connecticut. (Both, author's collection.)

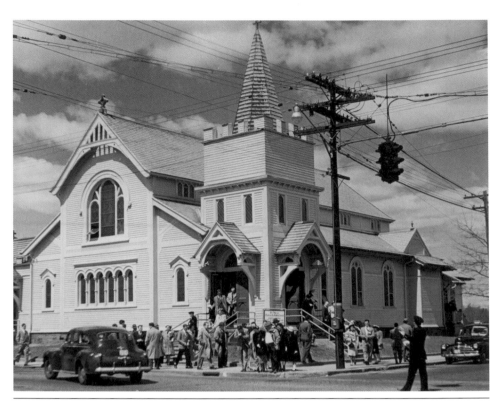

After construction of the New Haven railroad in the 1840s, a large number of Irish families moved to Milford. Because of the absence of a Catholic church, many of those families had to travel to New Haven for Sunday Mass. In 1850, the Rev. Edward J. O'Brien purchased land on Gulf Street to build Milford's first Catholic church, which was completed in 1853. In 1889, the Rev. Peter H. McLean became St. Mary's first pastor. In 1899, St. Mary's erected a new church, shown here at the corner of Gulf Street and New Haven Avenue. The current St. Mary's church is located at 70 Gulf Street and was dedicated in 1955. (TC.)

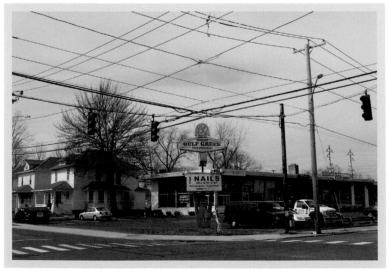

WORSHIP AND EDUCATION

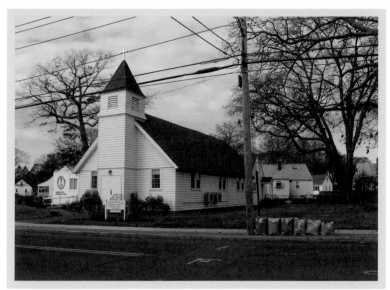

The Wildemere Beach Congregational Chapel, shown here in 1905, was organized in 1895 and located at 133 Broadway. The first Sunday morning service was held in 1920, and the church added its first full-time minister in 1925. In 1923, it became the Walnut Beach Union Chapel Society, Inc. In 1924, a kitchen was constructed along with a furnace room used for Sunday school teaching and the church proper. The parsonage was added in 1947, and a parish hall was included in 1950. The church was and is very family oriented. A countless number of Milford residents have been married there. Over 100 years later, mass is still held on Sundays, as well as Bible study and choir rehearsal. (Both, author's collection.)

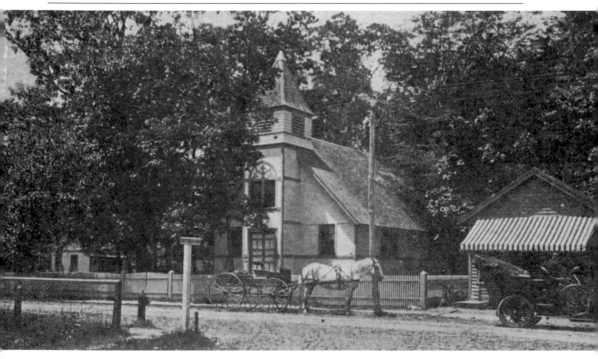

It must have been a wonderful experience to have grown up on the Milford shoreline and to have walked along the sandy beach to reach the Walnut Beach School. This was originally a four-room, two-story brick schoolhouse for the first through sixth grades. It was erected in 1916 on the corner of Stowe and Naugatuck Avenues at a cost of $21,571. In 1921, after adding eight more rooms, the seventh and eighth grades were added. Over the coming years with bigger and more modern schools being built, the Walnut Beach School was eventually closed and converted into apartments in 1980. (TC.)

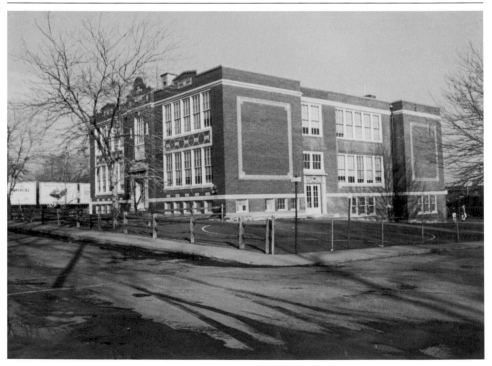

WORSHIP AND EDUCATION

Around 1917, before St. Ann's Church was located here at 501 Naugatuck Avenue, it was originally up the road on the corner of Naugatuck Avenue and Cottage Street and was called the Devon Chapel. St. Ann's was originally a mission church of St. Mary's and became an independent parish on August 5, 1924. The parish later purchased land on the corner of Naugatuck Avenue and Church Street and dedicated St. Ann's basement church on September 28, 1924. St. Ann's School opened in 1956, shortly before the present church was built in 1961 and dedicated in 1962. The stained-glass windows were created by designs of ink and water by renowned liturgical artist Jacob Renner, who emigrated from Munich, Germany, in the 1920s. (JC.)

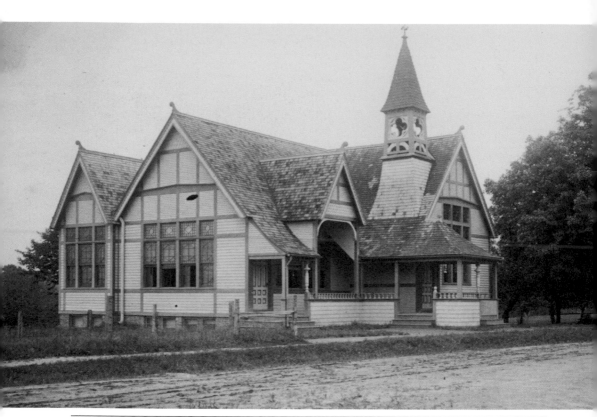

The Woodmont Union Chapel stands at the corner of Chapel Street and Merwin Avenue. The chapel was constructed and opened in 1887 as a nondenominational house of worship. A kitchen and dining room were added in 1896. It became the Woodmont United Church of Christ in 1969, which eventually moved to New Haven Avenue. This building then became the Woodmont Library until 1981. Today, the building houses the Evening Star Holiness Church. Not pictured but located just across the street on the southwest corner of Chapel Street and Merwin Avenue is the Bryan House, Woodmont's oldest home, built around 1790. (KKM.)

When the original Devon Union Church was incorporated in 1909 on Naugatuck Avenue across from the Devon Grammar School, there were only about 35 families living in Devon—then called Naugatuck Junction. After outgrowing the chapel on Naugatuck Avenue, the cornerstone for a new church was laid on the corner of Pequot Street and Ormond Street in February 1917, and the church's name was changed to Devon Union Church, as shown here. In the 1950s, the current brick building was erected. In 1962, the church joined the United Church of Christ, and the name was changed to the United Church of Christ in Devon. It is currently led by the Rev. Karl Duetzmann. (RKD.)

St. Agnes Chapel was originally opened by St. Mary's Roman Catholic Church in 1906 to accommodate summer parishioners in the Woodmont area. St. Agnes Chapel was located here on the corner of New Haven Avenue (now Kings Highway) and Center Street (now Dixon Street). To the right was the Woodmont School, which originally opened as a two-room school in 1918 and was expanded in 1927 with two more rooms to accommodate pupils from kindergarten through sixth grade. This location is now home to the Ellen Aftamanow Woodmont Volunteer Library, and the Woodmont School is now the Fannie Beach Community Center. To the right of the school once stood Woodmont's original firehouse, which was a barn in 1897. (Author's collection.)

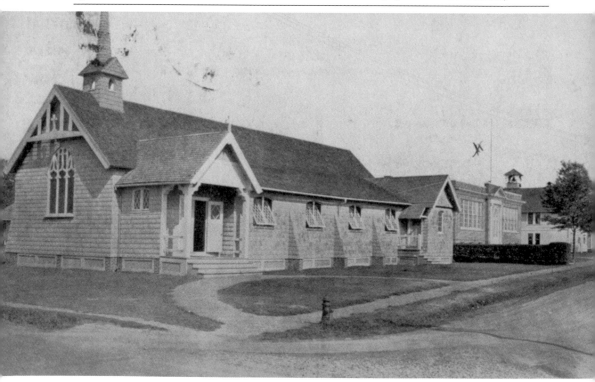

FORT TRUMBULL BEACH

The Pilgrim Cottage Store and Lunchroom, pictured around 1915 at the corner of East Broadway and Seaside Avenue, accommodated summer residents and visitors in the Fort Trumbull Beach area. The Maroneys were the owners of the Pilgrim before it was later acquired by Joe and Richard Smith. Over the years, the popular Pilgrim restaurant changed hands and expanded multiple times. It became T.J. McKiff's sometime in the 1980s and was eventually razed to make way for private residences. Gone are the days of 40¢ quarts of ice cream. Richard Smith Jr. is the current owner of the Seven Seas Restaurant in Milford center, which has been operated by his family since 1965. (MGG.)

Pictured around 1915, the old fort, last known as the Clapp House, was built around 1812. It was the location of Fort Trumbull, which was named after Jonathan Trumbull, Connecticut's Revolutionary War governor from 1769 to 1784. In 1776, the fort was armed by a Mr. Herpin and 25 soldiers, including officers and six cannons. The fort protected Milford Harbor from British ships that were in constant search of supplies along the shoreline villages. It is speculated that when the old fort was built, it was done so to help slaves escape to Canada. In the 1860s, the lawn extended out 100 feet farther and consisted of a tunnel guarded by a cannon. In 1981, this historic building was replaced by condominiums. (MGG.)

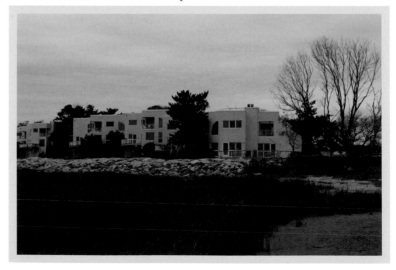

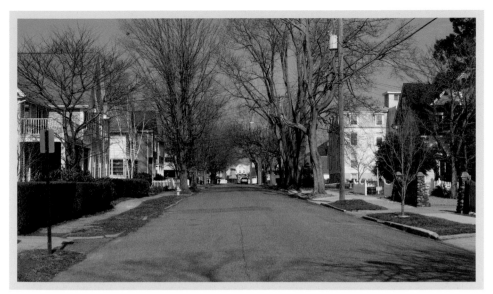

This family, complete with the family dog, poses next to a gas-powered street lamp on Shell Avenue in the early 1900s. This view is looking east running parallel to the beach toward Seaside Avenue. The third house on the right is the Seabreeze Hotel; it was run by Richard and Ruth-Ann (Magen) Herman and Bess Magen from 1948 to 1959, after which it was sold and remodeled into apartments. To the right of the Seabreeze was the Magen cottage, built in 1895 by brothers Nathan and Jacob Magen. This cottage has since been converted to a two-family home. Descendants of the Magen brothers still own and reside in this home. (NH.)

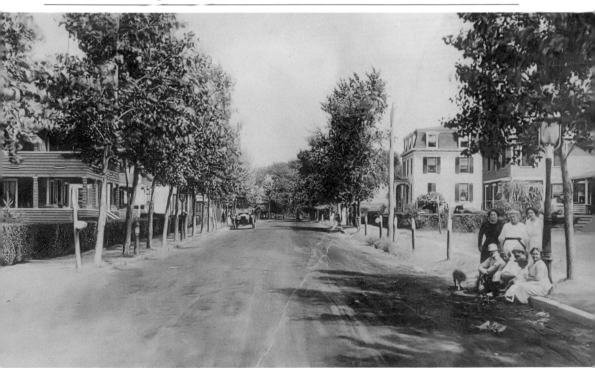

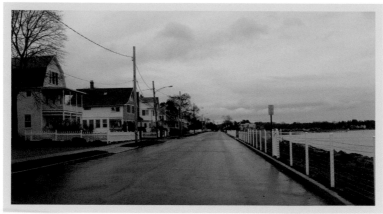

Looking east on this small strip of roadway on Trumbull Avenue, better known as "the Drive," toward the Milford Harbor is Milford's historic Fort Trumbull Beach. During the Revolutionary War, Fort Trumbull helped protect the citizens from the British. Gov. Jonathan Trumbull, for whom this area is named, was a friend and advisor to Gen. George Washington during the war and was the only colonial governor to take sides with the rebel cause. Many historic buildings in this area still stand today, such as the Willard Hotel, the Seabreeze Hotel, and the Gables, built in the 1880s and occupied by Henry Augustus Taylor as his summer resort. (MGG.)

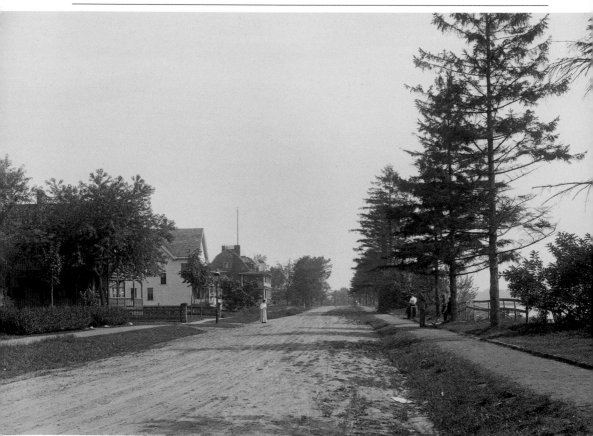

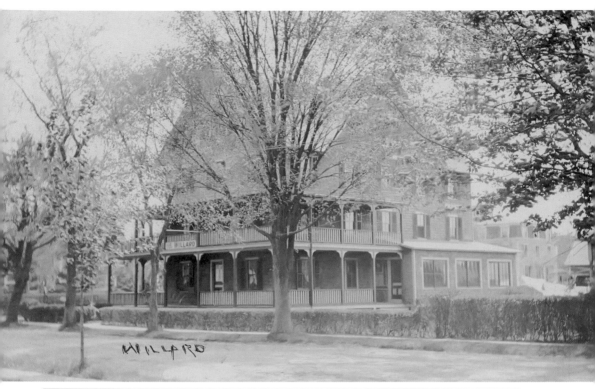

In the late 1800s, the Willard Hotel located on the corner of Seaside Avenue and Shell Avenue was owned and operated by Walter and Martha Maroney, who were also at one time the owners of the Pilgrim restaurant, situated just around the corner on East Broadway. In the center right background of the older photograph, one can also see the Seabreeze Hotel. In the background to the left overlooking Fort Trumbull Beach was the Gables, Henry Augustus Taylor's summer home. The Gables later became a convent and was eventually purchased in 1980 and was converted to condominiums. The Willard Hotel's building still stands intact today and is currently used as apartments. (Author's collection.)

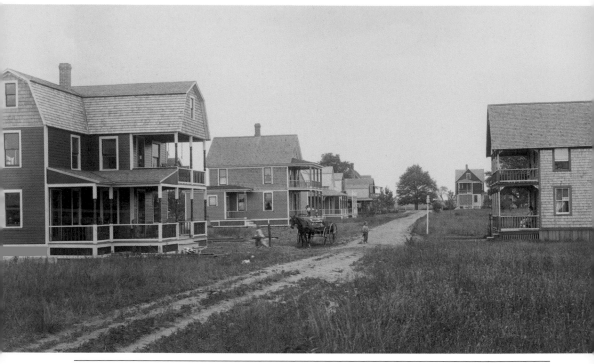

This c. 1915 photograph was taken looking east toward Seaside Avenue on Willow Street. With the dirt road showing very little wear from horse and carriage travel, it was evident that this was a fairly new street. Willow Street was located a few blocks north of Fort Trumbull Beach and just south of the onetime palisades. The palisades were 12-foot-high barricades built around the downtown Milford area as protection for the colonists during the 17th century. This area was known as "Bear Neck," at one time, a term still used by some today. The Then photograph shows a horse and carriage—a common form of transportation in those simpler times. The first house on the left was built in 1910 and still stands today. (MGG.)

The Milford Yacht Club, seen here, sits just inside the mouth of the Milford Harbor. The club was formed in large part due to the efforts of Dr. Willis A. Putney, who became the first commodore in 1903. The Yacht Club purchased this rental property in 1926. In 1932, a group of young sailing enthusiasts purchased an old schooner and docked it halfway up the harbor at Spencer's Wharf to use as their clubhouse. They called it the Wepawaug Yacht Club. In 1934, both clubs merged and kept the name of the Milford Yacht Club. The yacht club today still offers multiple programs for boating enthusiasts of all ages. (MYC.)

Looking east on East Broadway, one block north of Fort Trumbull Beach, this c. 1915 photograph shows the trolley tracks that visitors and locals traveled on to reach the beach and to their summer cottages and hotels. One could stop by the Pilgrim Cottage Store and Lunchroom, shown here on the left, to pick up vacation necessities, such as groceries, swim suit rentals, and postcards to send back home. One could inquire about cottage rentals, as well as pick up a 20¢ pint of Harris-Hart Company ice cream. Today, new homes have filled the barren lots, including a modern convenience store a few houses down on the left, replacing the Pilgrim Cottage Store and Lunchroom. (MGG.)

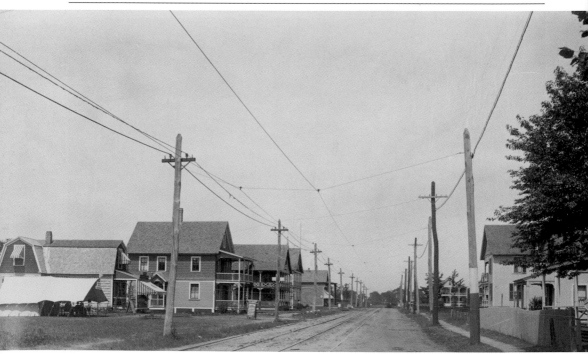

COASTAL SCENES

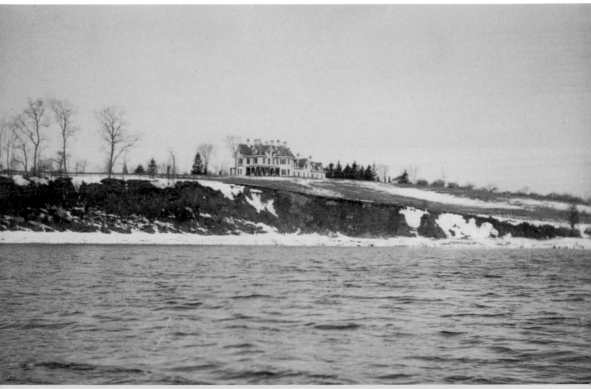

Miles Merwin, one of Milford's original colonists, settled in this area in 1645. Sixteen generations of the Merwin family were to follow. In 1860, Henry G. Thompson purchased this land from the descendants of Miles Merwin. This photograph of Henry G. Thompson's 22-room manor, seen here high on Morningside's bluff, was taken around 1880. The Thompson mansion had many luxuries for its time, including running water throughout the building, a milk room, an ice room, and a furnace room. Thompson's estate also consisted of a carriage house, barn, tool house, and the superintendent's home. After Thompson's death in 1903, the property was sold to the Yale family, divided into lots, and sold for residential homes. (TFM and CP.)

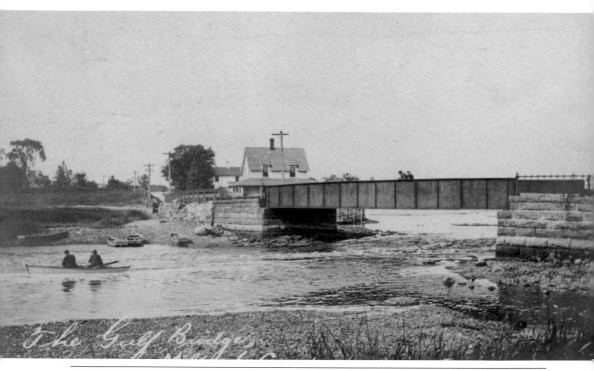

The Gulf Street Bridge, shown here in 1906, separates Gulf Pond from the mouth of the Milford Harbor. The original Gulf Street Bridge was erected in 1713, followed by another bridge that was completed in 1810. In 1938, the bridge was ripped from its moorings during a devastating hurricane. Today, the older bridge serves as a fishing platform for local fishermen and has been replaced by a more modern bridge to handle today's traffic. During the 1940s, Yale archeologists discovered and excavated an Indian burial site on the Gulf Pond side of the bridge. More graves were discovered in the 1950s, and again in 1983; the remains were turned over to Connecticut's Paugussett tribe. (TC.)

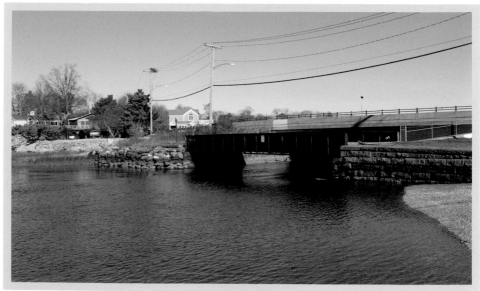

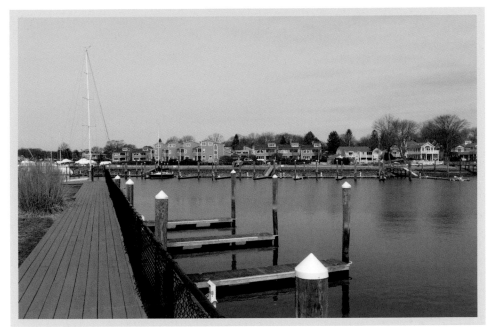

This c. 1915 photograph, taken from the grounds of the Milford Yacht Club, shows the yacht club's boat landing near the mouth of the Milford Harbor. The buildings across the harbor were William Merwin's oyster docks that started a local industry in 1752. At the mouth of the east side of the harbor is Gulf Beach, and directly across, on the west side of the harbor, is Fort Trumbull Beach. This harbor was responsible for much of Milford's trade and shipbuilding when the early settlers arrived. Today, the harbor boasts numerous marinas, including Milford Landing at the head of the harbor, that provide docks for transient and commercial fishing vessels. (MGG.)

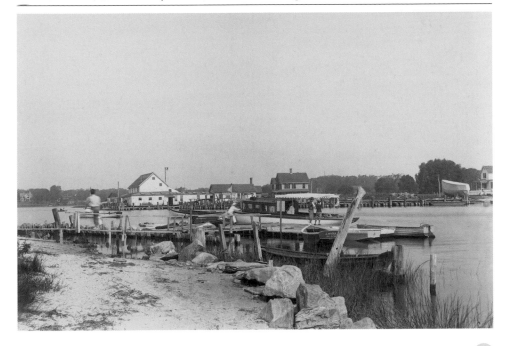

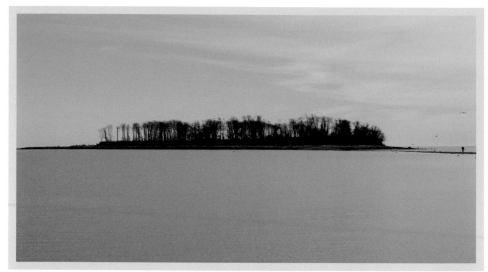

Long before the colonists settled in Milford, this island was called "Poquehaug," the name given to it by the local Native Americans. When the colonists arrived in Milford, Poquehaug was used as a summer Wigwam by Ansantawae, the sachem of the Paugussett tribe. After receiving permission from the town, Charles Deal purchased, on March 17, 1657, Poquehaug from Richard Bryan, who had acquired it from George Hubbard. Over the years, Charles Island, named after Charles Deal, has been a tobacco farm, summer resort, fishery, and a monastery. Today, Charles Island is a nature preserve and a breeding ground for local birds, such as the Little Blue Herons and Great Egrets. (ERB.)

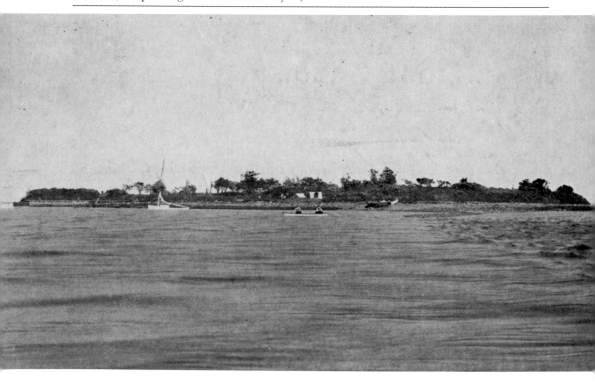

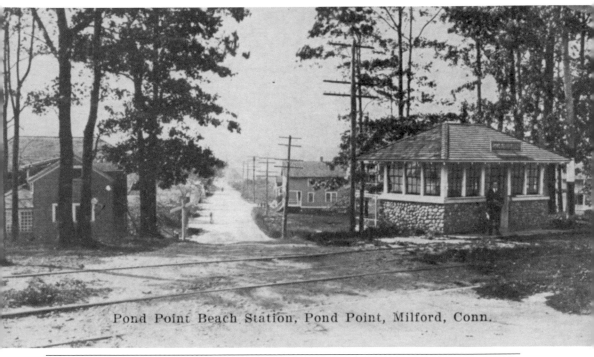

Pond Point Beach Station, Pond Point, Milford, Conn.

The Pond Point Beach station was a trolley stop on the corner of Buckingham Avenue and Melba Street and was one of many stops for travelers from Bridgeport to New Haven. The first trolley line in Milford was installed by the Bridgeport Traction Company; the line was later extended into Woodmont by a New Haven company. Trolley transportation created a real estate explosion that caused Milford's summer resort business to boom. Today, the Bayview Beach area, seen straight ahead, is home to both small seasonal cottages and large year-round homes. (Author's collection.)

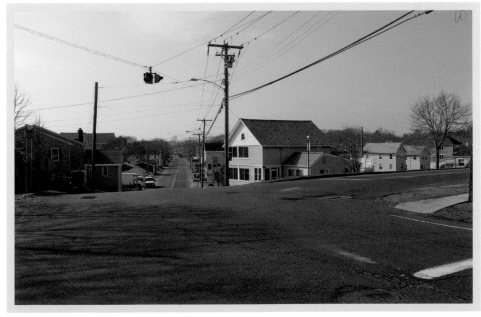

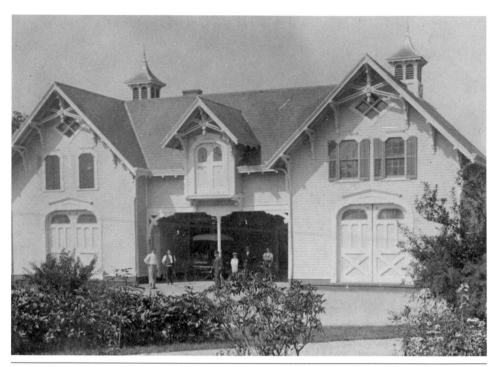

The carriage house on Henry G. Thompson's 100-acre estate in the Morningside area of Milford was also known as Rock Farm. Shown here around 1900 are, from left to right, Thomas F. Maher, John, Mr. Feltis (coachman), Pop, Henry, and estate workers (full names unavailable). At one time, the carriage house held several work and riding horses, including two white horses used to pull a classy carriage driven by the coachman. Just below the carriage house were large vaults used to store grain. Years later, the house was remodeled to become the Anaconset Club that featured a dance floor, card games, and billiards. During World War I, the basement of the club was used as a bomb shelter. Today, the carriage house serves as a private residence. (TFM and C.P.)

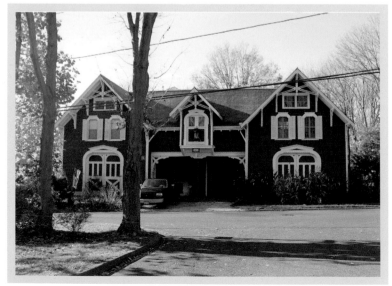

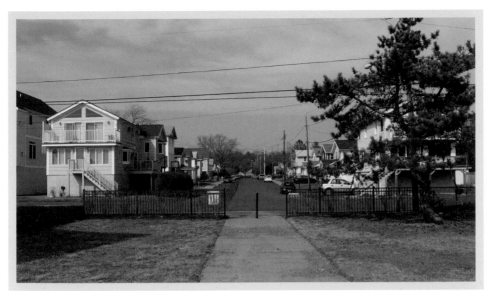

Not much has changed on Coolridge Road in the Point Beach area of Milford, except for a less open land and more large homes. This scene looks north across Point Beach Drive onto Coolridge Road. South of this scene overlooks Long Island Sound. Due to the sea level in this neighborhood, the resilient Point Beachers have endured some tough times with hurricanes. Now, sirens warn residents in advance of approaching storms and flooding. Point Beach School opened its doors on May 9, 1949, and closed in June 1982 to be converted to condominiums. (Author's collection.)

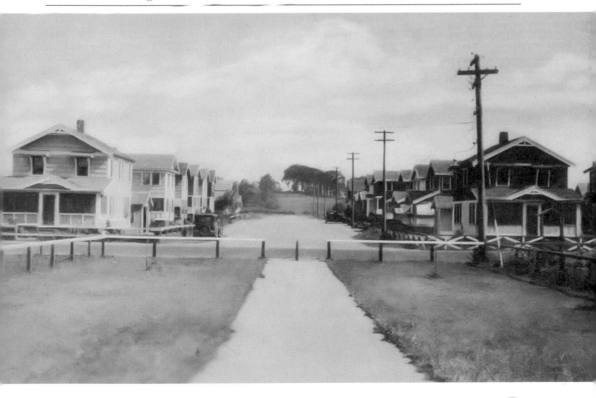

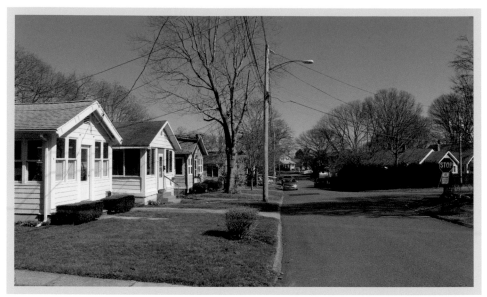

This small neighborhood of Bayview Beach is located just west of Point Beach and east of Gulf Beach. Bayview Beach boasts 600 feet of beach owned by the Bayview Beach Association. It was incorporated in 1921 and was managed by a board of governors that included a clerk and treasurer. Bayview Beach has its own neighborhood watering hole called the Beachcomber Café, which has catered to local residents for decades. With its own grassy green area, the community has been holding its own Fourth of July parade for over 30 years. (Author's collection.)

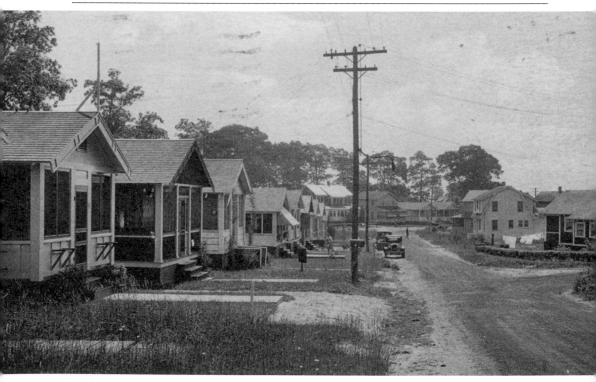

THE WOODMONT BOROUGH

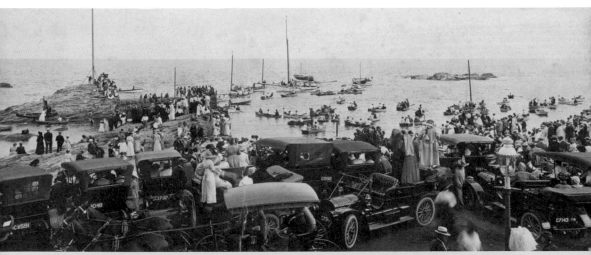

Woodmont Day is an annual event with attractions like the races shown here. This 1917 event, held in the borough of Woodmont, would attract travelers to the area by trolley, automobile, and even by boat. This scene shows the popular annual races on Randalls Point. Just to the left is Crescent Beach and to the right of this scene is Anchor Beach. Woodmont itself has approximately 1.5 miles of shoreline, much of it consisting of large shale rock formations. If one were to remove the vintage vehicles, horse-drawn buggies, and gas-powered lamps, this scene would look very similar to present-day Woodmont. Woodmont Day is still held every year at the Hawley Avenue playground on the last Saturday of July. (TFM and CP.)

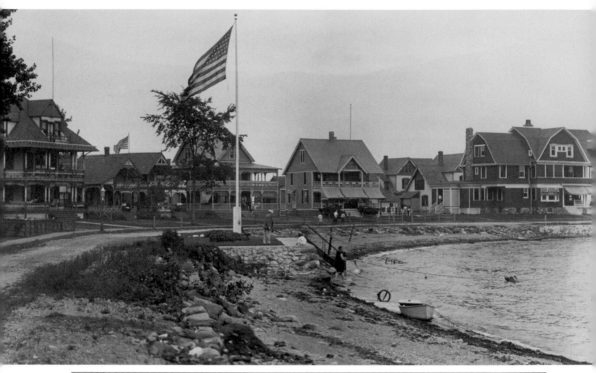

Crescent Beach, shown here 110 years ago in 1906, was one of many beaches in Woodmont that also include Anchor Beach, Merwin Beach, Long Beach, and Anderson Avenue Beach, the most popular being Anchor and Crescents Beaches. The building to the far right was the Blakeslee cottage owned by Charles Wells Blakeslee, who was the owner of a construction business established in New Haven, Connecticut, in 1844. Before the roads were paved, they were just dirt roads. In 1910, the Woodmont Borough board voted to oil Beach Avenue to keep the windswept dust at bay. This area is still popular among sightseers, bathers, and fishermen. (NHM.)

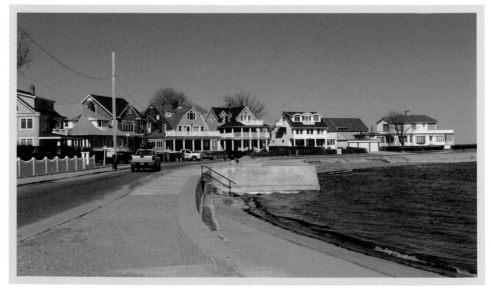

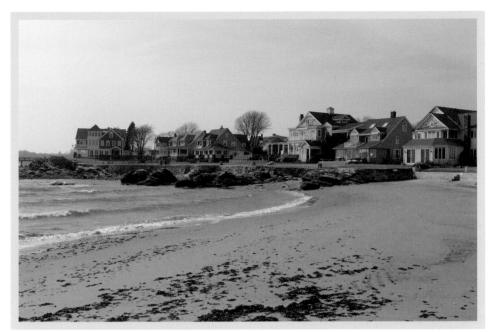

Anchor Beach, seen here around 1901, is set between Merwin Point and Randalls Point. Anchor Beach happens to be the only naturally sandy beach in all of Woodmont. The property that jets out straight ahead is Merwin Point; during the 1800s, it was owned by John W. Merwin, who eventually sold for building lots. The stones for the stone walls were gathered when the fields in this area were cleared for residential construction. The boats moored were most likely being used for blue fish and mackerel fishing, which was popular on the Woodmont shoreline. (KKM.)

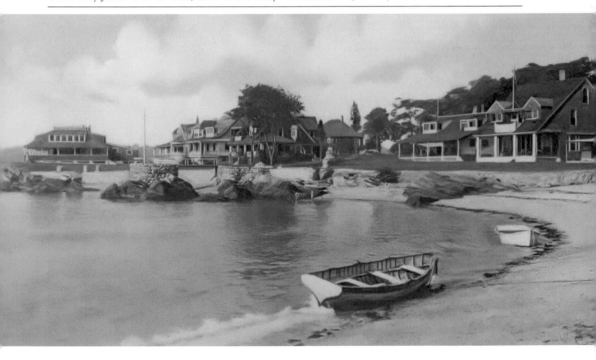

This c. 1901 photograph shows two boys standing at the intersection of Central Avenue (now Dunbar Road) and Hawley Avenue. Woodmont's Seaside Pharmacy, known for its soda fountain, comic books, and penny candy, published this postcard. As one can see, the home to the left still stands today with some changes that include enclosing the front porches on the first and second floors. The Woodmont Association was established in 1901 and formed as a community improvement organization. The Borough of Woodmont became official on June 18, 1903, with elected officials having the authority to collect taxes, build roads, and control health and sanitation. The new borough hall is now located in the old firehouse on Kings Highway. (KKM.)

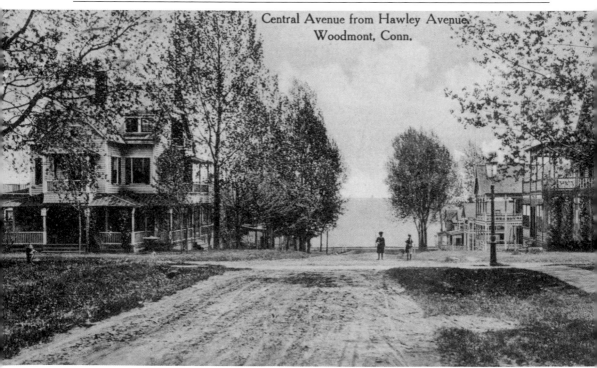

Central Avenue from Hawley Avenue, Woodmont, Conn.

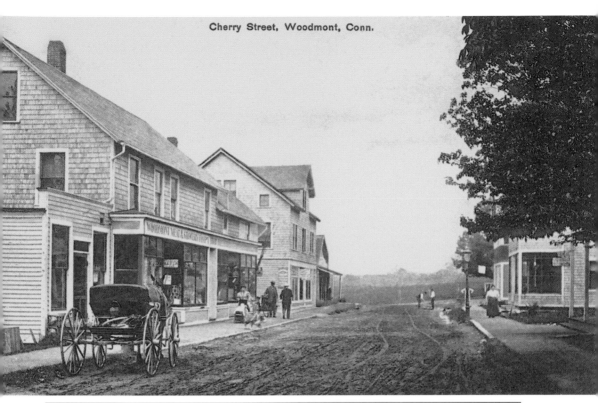

Cherry Street, Woodmont, Conn.

Looking north on Cherry Street (now Village Road), this photograph shows people going about their daily business. Woodmont Meat and Grocery Company, which was also at one time Peterson's market, and Clark-Hall hardware are visible in the image. Today, this is the location of Scribner's restaurant, which has been in business for 59 years and running. Looking straight ahead, the land was open and undeveloped compared to today's sprawling neighborhoods. The other store to the left was once J.A. Hall Plumbing, and some years later, the building next to it became Susman's department store. Across the street was the local post office and Harris-Hart ice cream. (KKM.)

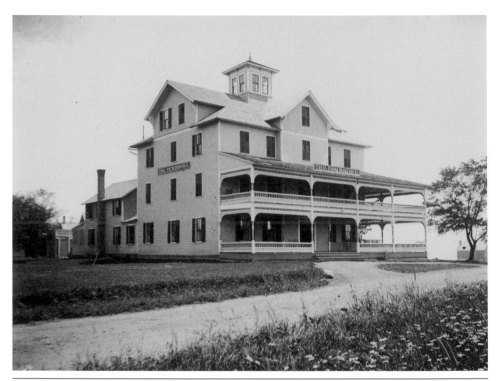

The Pembroke Hotel, pictured around 1900, was on the corner of Main Street (now Chapel Street) and Vue De L'eau (now Hawley Avenue) and was possibly built around 1875. It was the largest of the many hotels that catered to summertime visitors in the borough of Woodmont. Before an addition was added in 1906, the hotel provided accommodations for approximately 100 guests and also provided transportation via horse and wagon to pick up hotel guests from the Woodmont train station. The Pembroke Hotel has since been razed. In 1959, the Seaside Convalescent home was built; later, it was converted to condominiums. (KKM.)

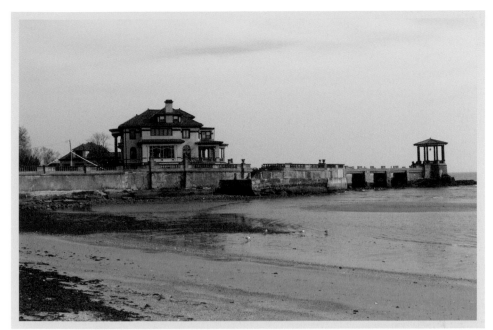

In September 1881, at the age of 23, Sylvester Z. Poli, born in Florence, Italy, on December 31, 1858, arrived in America. Soon after, Poli met and fell in love with Rosa Leverone, and the two were married in 1885. Sylvester Poli became a very successful movie theater magnate who founded Poli Theatrical Enterprises, which owned a chain of 28 theaters that he operated between 1907 to 1925. Around 1913, Poli constructed Villa Rosa Terrace, named after his wife, Rosa. He also built 10 waterfront cottages on the property. Some of Poli's guests at the Villa Rosa Terrace were Charlie Chaplin, W.C. Fields, and Al Jolson. (KKM.)

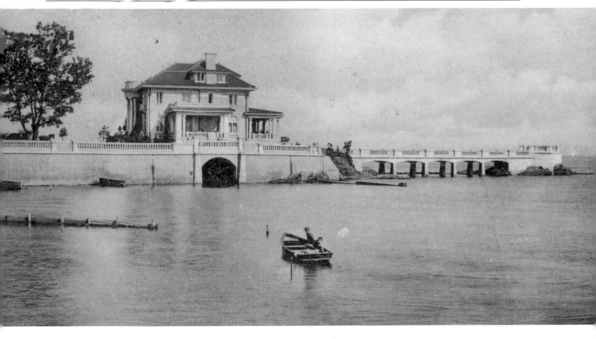

The Woodmont Lodge was once located here on the corner of Mark Street and Kings Highway. This postcard of the lodge was dated 1939 and was mailed to Madeline Ross of New Haven, Connecticut. In the 1880s, long before the Woodmont Lodge, this building was first known as the Mark Merwin House and then as the Merwin Point House. The Woodmont Lodge was managed by George and Molly Volk who also owned the Hotel Volk in New Haven, Connecticut. Albert Einstein, a frequent summer guest at the lodge, was said to have loved the way George Volk prepared his mackerel dishes. Today, this property now houses the Woodmont Shores condominiums. (KKM.)

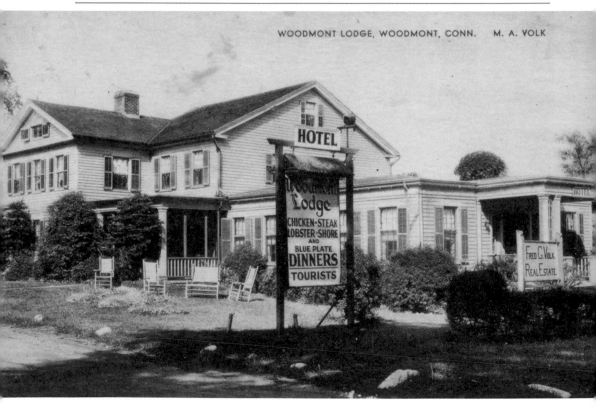

This c. 1917 photograph shows the Villa Rosa trolley stop at the corner of Merwin Avenue and Abigail Street, built in 1927. Local residents picked up at this trolley stop were taken to the popular destination of Savin Rock Amusement Park, located just over the town line in West Haven. The area pictured separated Woodmont's western end from Milford. Approximately two years after this photograph was taken, in 1919, electric lights replaced gas streetlights. George Kittle, a former longtime resident of Woodmont, would reminisce about how he used to clean and light the gas street lanterns by hand. (KKM.)

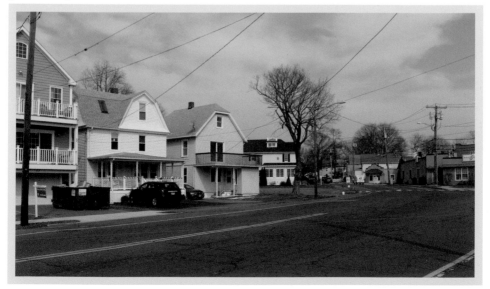

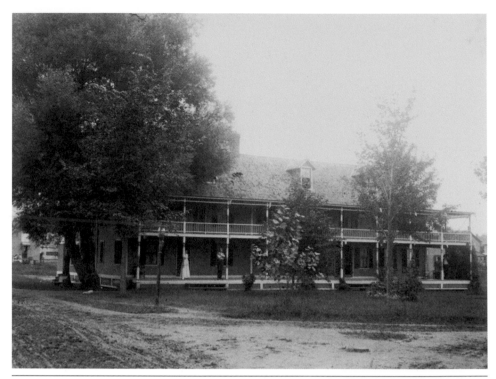

The Sanford House is pictured around 1900, which was before an addition was made to the house in 1907. The structure was on the corner of New Haven Avenue (now Kings Highway) and Beach Avenue; it was one of the largest and most popular hotels in Woodmont. Trubee Doolittle, a longtime resident of Woodmont and borough secretary for many years, purportedly spoke of a story told by his mother that they once lived in a tent on a barren lot in Woodmont until a storm blew away the tent—his mother was left standing there holding him as a baby in her arms. His parents later purchased that lot, built a home, and lived there. (KKM.)

HISTORIC MILFORD

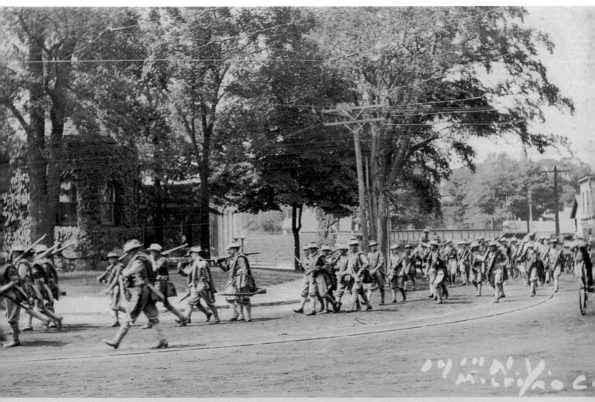

American Army soldiers flex some muscle marching up River Street and onto Broad Street on the Milford Green in 1912, while pedestrians go about their daily business watching the massive display. In 1912, the Army and National Guard conducted war games in the area with over 20,000 soldiers participating, including military planes that were the first ever used in a military training exercise. Acting as the invaders, the red army was stationed in Milford, while the blue army was stationed on Paradise Green in Stratford. The Taylor Memorial Library is in the background to the left. (DRM.)

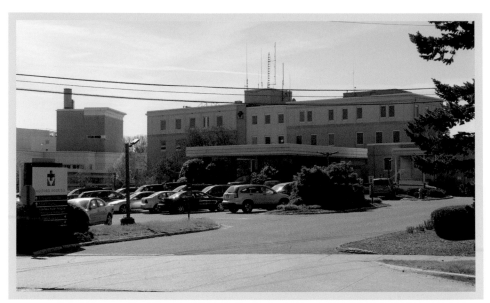

The Clark-Stockade House, shown here on February 25, 1922, was originally the home of Deacon George Clark in 1659. Just before this date, a 12-foot wall was erected around the center of town to protect the colonists from Indian attacks and from the Dutch in the northern part of the state, with whom the English had constant clashes. The wall was referred to as the palisades, and the Clark-Stockade House was the first home to be built outside of it. The house was also temporarily used as Milford's hospital. The house was moved to its present site on High Street in 1974 and is currently part of the Milford Historical Society. (NHM.)

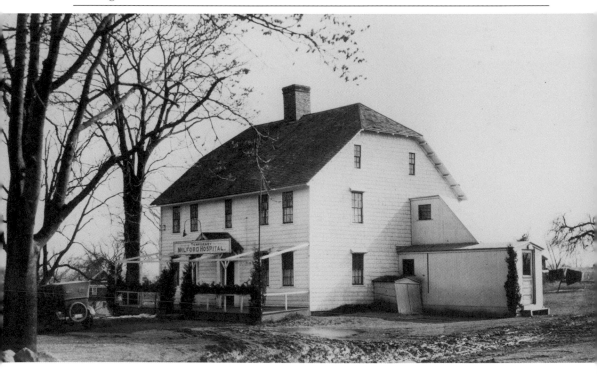

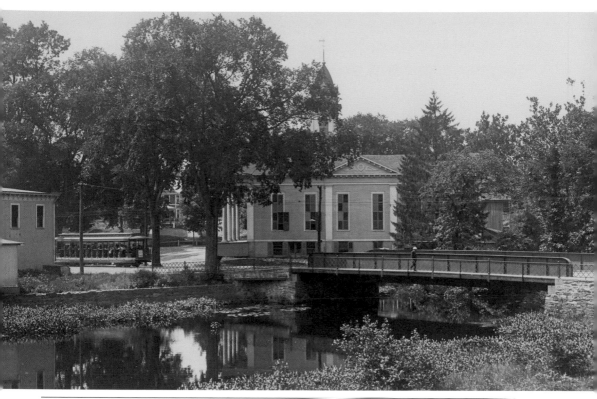

Built in 1802 and named after Thomas Jefferson, the first Jefferson Bridge was constructed by the New Haven and Milford Turnpike Company. The second bridge was built of wood in 1837. The third bridge, made of iron, was built in 1878 at a cost of just over $2,000. A brick roadway was added later. The fourth bridge was made of steel, and with the addition of trolley tracks, was completed in 1898. The fifth and current bridge, built of stone and concrete in 1935, has three and is similar to the bridge in Milford, England. In honor of Milford's three governors, a stone bench monument on the bridge was erected in 1939 for the town's 300th anniversary. (NHM.)

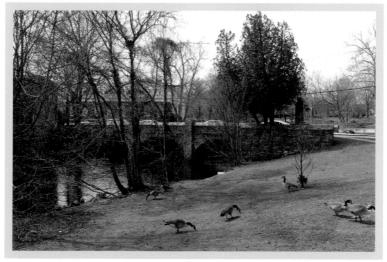

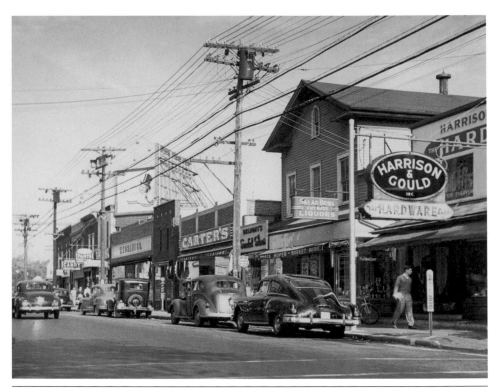

Charles W. Harrison and Alfred E. Gould opened Harrison & Gould, Inc., hardware store, shown here in 1949, in 1907. Before Harrison & Gould, this building was the home of J.H. Barnes pharmacy and hardware. Sometime before that, the building was occupied by J.O. Silliman Company, which manufactured Army shoes during the Civil War. Some other well-known stores on this street were Carter's, Belmont shoes, and W.T. Grant. After a fire destroyed then-named Harrison's hardware store in 2006, the Colony Grill brought new life to Milford center on May 20, 2013. (TC.)

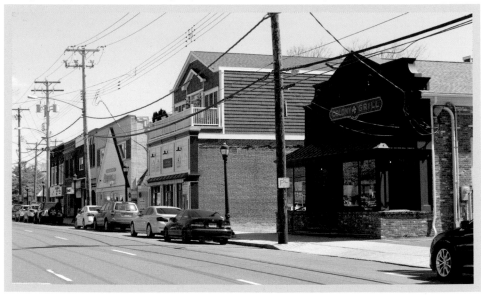

By the early 1900s, horseless carriages on River and Broad Streets were becoming common sights. Trolleys, like the one seen here, arrived in Milford in 1898 via the Bridgeport Traction Company. The corner of River and Broad Streets was home to an automobile shop, Hyatt Photography (known for its postcards), Chaitlin's, a French bakery, and the popular Issie's Newsroom. Today, the second floor of the corner building is home to *The Dan Patrick Show*, a radio and television sports talk show. (DRM.)

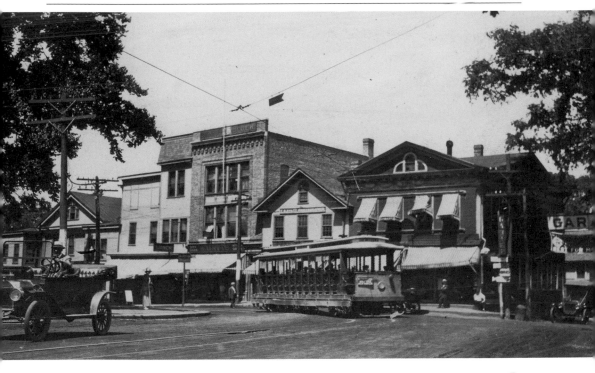

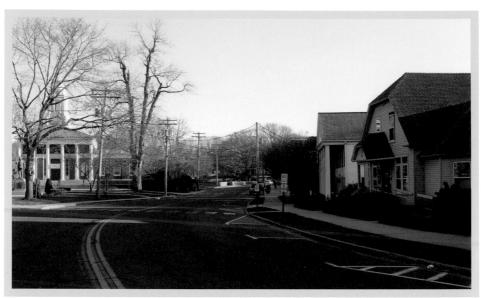

This wintery scene of a horse-drawn carriage riding south on River Street was captured on February 20, 1910. The building that housed Milford's first fire company, founded on May 28, 1838, is pictured up the road on the left side of the street. The Gothic-style building on the far left of the photograph housed Milford's town hall. In 1874, the original town hall structure (just out of sight to the left of the photograph) was joined with a Baptist church (pictured) with a central section. The town hall was also home to the grade school, high school, and the town jail, and later, the old Baptist church side of the building became a silent movie theater. On February 19, 1915, a fire destroyed the entire structure. The new and current town hall was completed in 1917. (NHM.)

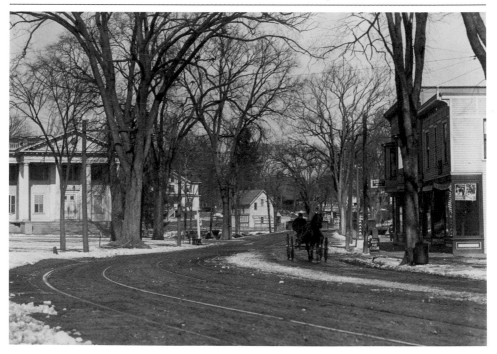

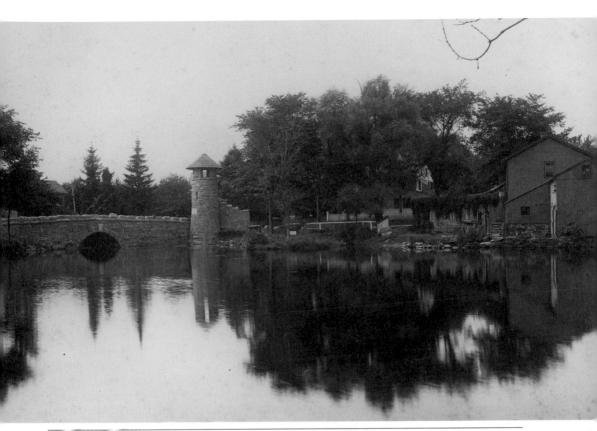

This 1889 photograph was taken looking south at the Memorial Bridge over the Wepawaug River from Prospect Street. That same year, Memorial Bridge was built to celebrate Milford's 250th anniversary. The first bridge at this location, built in 1645 by William Fowler, was a wooden bridge. Thirty blocks of granite along the bridge bear the names of Milford's early settlers. Today, this busy downtown area, with its New England charm and numerous restaurants and shops, is a big attraction for visitors. (NHM.)

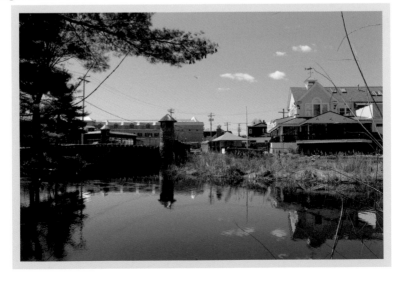

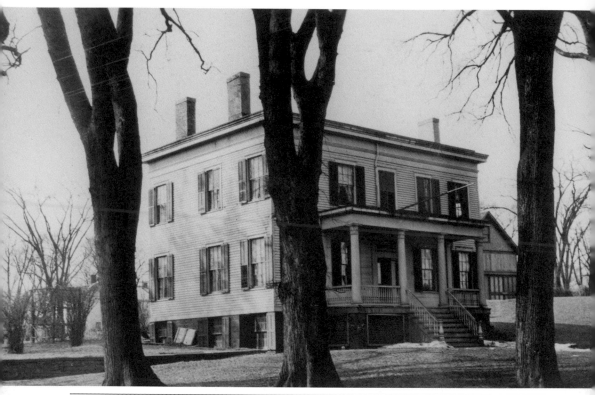

Located at the west end of the Milford Green was the Carrington house, shown here in 1922; Nelson Carrington built the home. In 1853, Nelson Carrington along with Levi Langridge was given permission to install a fence around the Milford Green. They traveled to New Haven to pick up a secondhand wooden fence that once surrounded the New Haven Green. The Grand Union supermarket, built by William Carlson, was later located here. In 1978, the Grand Union was purchased and remodeled by Danforth M. Smith and Deforest W. Smith and is the current home of Pearce/George J. Smith Realtors and George J. Smith & Son Insurance. (NHM.)

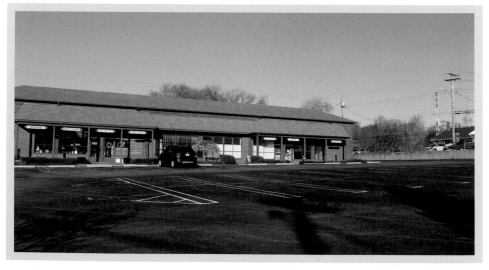

Before it was the Daughters of the American Revolution (DAR) Milford Chapter House, constructed in 1907 and shown here in 1949, this was the site of the Visher's Milford house and livery stables in the mid-1800s, and then followed by the Milford house. This corner on North Broad and Depot Streets is now home to the Milford Bank, which, at one time, was located in Mr. Bristol's store on Broad and Center Streets. The DAR has since moved to Prospect Drive on land that once belonged to Rev. Peter Prudden. (TC.)

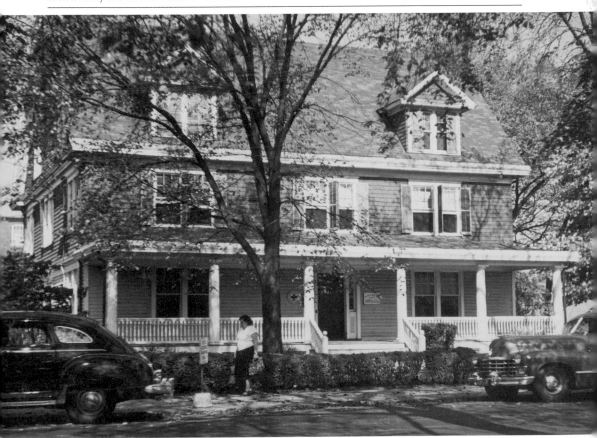

Now a condominium complex, this building was once home to a number of manufacturing companies. One of those companies was the Baldwin and Lampkin Company, a shoe factory that moved into this location on Broad Street from Golden Hill Street in 1875, employing more than 200 workers. Men stitched the seams, and women sewed on the bindings. The company was so successful that it enlarged in 1885, but in 1903, after financial difficulties, it was forced to close. Next was the Reeves Manufacturing Company that produced meters and the Reeves suction sweeper. The longest-running company here was Waterbury Lock, which closed its doors in 1984. (TC.)

The lower part of High Street was once called Wharf Lane and is one of Milford's oldest roads. A busy dock occupied the end of Wharf Lane. Maybe the oldest home in Milford, which dates back to the late 17th century, the Eells-Stow House still stands today in its original spot and is joined by the Clark-Stockade House and the Bryan Downs House. All three homes comprise the Wharf Lane complex of the Milford Historical Society. Behind these homes are granite steps that used to lead to Clark's Tavern on West River Street; Pres. George Washington allegedly once stayed at that tavern and walked up those steps. (DRM.)

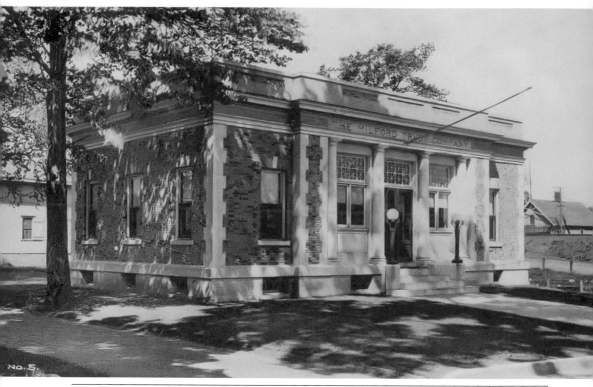

In 1912, the town's first commercial bank, the Milford Trust Company, was incorporated. Also constructed that same year was this building on River Street, just behind the Taylor Memorial Library and across the street from McDean's newsroom, a gathering spot for the town's source of news. In 1961, this building became the Town Squire Men's Shop, owned and operated by Michael Petrucelli, who was and still is a very active member of Milford's community. The building has been occupied by Milford Photo since 1995. (Author's collection.)

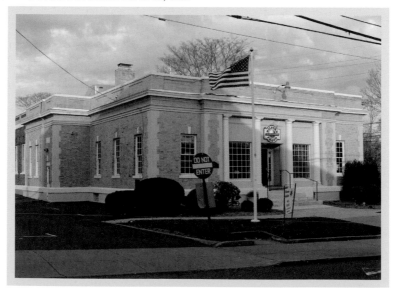

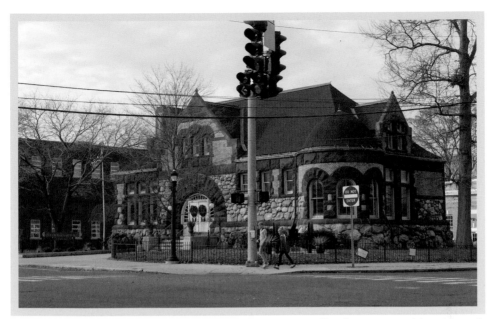

On the corner of Broad and River Streets sits the Taylor Memorial Library, shown here in the 1910s. The building, with its brownstone, red tiled roof, and Roman arches, was designed by New Haven architect Joseph W. Northrop. On April 10, 1893, Henry Augustus Taylor, a wealthy developer and part owner of several railroad lines, offered to build and present a library to the town; it was an offer that was quickly accepted. The town purchased this land from W. Cecil Durand for $3,400. Taylor's cost for the construction of the library was $25,000. The library was dedicated on February 2, 1895. The library moved to New Haven Avenue in 1976, and this building is now home to the Milford Chamber of Commerce. (Author's collection.)

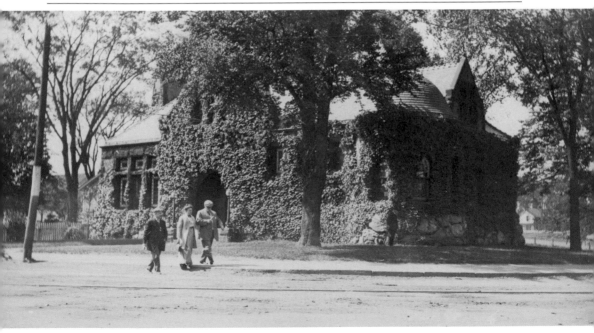

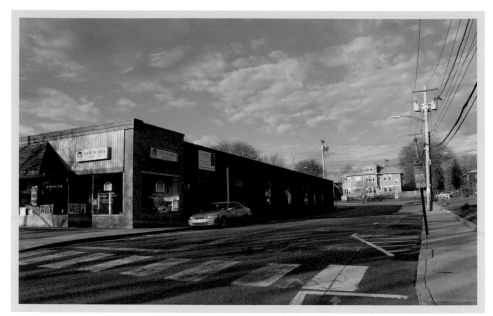

This unique Italianate villa-style mansion on the corner of River Street and Darina Place was decorated to celebrate Milford's 275th anniversary. The mansion was called the "Darina," which means "happy home" in Arabic, and was built in 1853 by Harvey Beach, a carriage builder from New Orleans. Shown here in 1914, it was owned by the Jervis D. Brown family. This beautiful home was razed in 1941 to make way for a new A&P store. Donahoe's, a popular soda shop among the local schoolchildren, soon appeared on this corner and, later, moved across the street. The A&P store closed in 1975 to be remodeled and turned into smaller stores. (TC.)

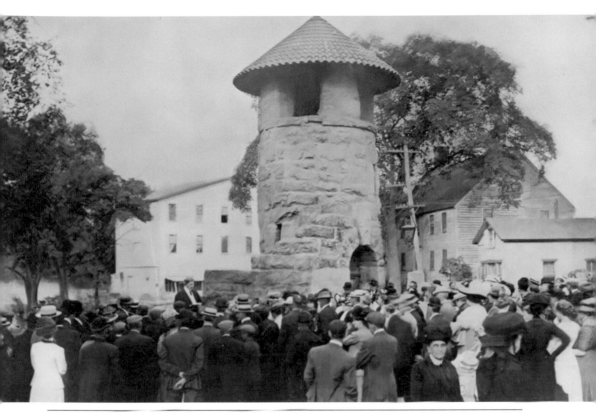

This c. 1900 open-air gathering at the Memorial Tower included descendants of early Milford settler Thomas Sanford. The Memorial Tower and Bridge, built in 1889, was designed by William Milne Grinnell of New York. The granite stone was brought in from Leete's Island in Guilford, Connecticut. Just to the left of the tower stone wall is a millstone that is said to be the original millstone from William Fowler's mill in 1640. To the left of the millstone is a memorial in honor of Daniel S. Wasson, the first Milford police officer killed in the line of duty on April 12, 1987. (DRM.)

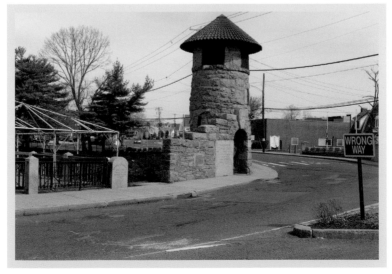

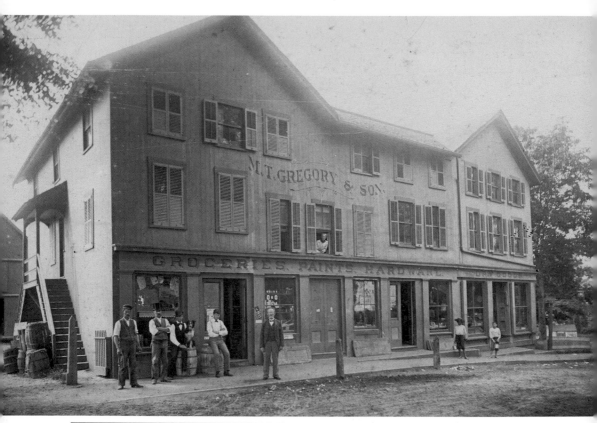

Moses Tulley Gregory, born February 20, 1839, started the M.T. Gregory & Son grocery store on the corner of Cherry and Prospect Streets. It was later handed down to his son Nathan Gregory before Moses's death in 1924. The space above the store was rented as boarding rooms. In 1952, this building was used as the Milford headquarters of Dwight D. Eisenhower, who went on to serve as US president from 1953 to 1961. Later in 1952, the *Milford Citizen* newspaper moved into that building. The barn seen to the left burned down a decade later. The Gregory Building is currently a dental care office. Across the street was the site of Milford's earliest post office, dating back to 1824. (MHS.)

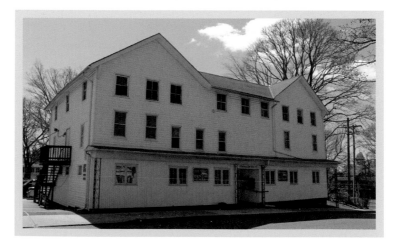

THE VILLAGE OF DEVON

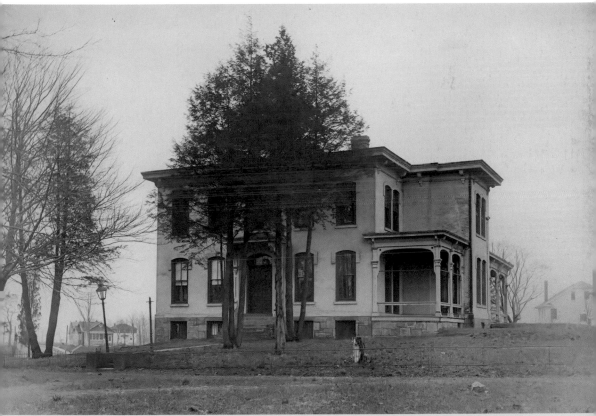

One of Devon's historic gems is the Hubbell Mansion, also known as the "Rivercliff," located on Crescent Drive just off Hubbell Place. This Civil War–era mansion was built in 1864 by Orange Scott Hubbell, a pharmacist and botanist. The builder's name was Hezekiah Baldwin Beardsley, who also built Lauralton Hall, the former home of Gov. Charles Hobby Pond. The Hubbell Mansion overlooked the Housatonic River on more than 100 acres, stocked with horses and cattle. Some say that the mansion was once a hiding place for slaves along the Underground Railroad. To this date, the Kowalski family was the longest-running owner on record before selling recently. (TC.)

This shot was taken on the corner of Bridgeport Avenue and Naugatuck Avenue sometime in the early part of 1900. At one time, the top of the building to the right housed the Devon Improvement Association, and later, it hosted the Devon Library. Before the Bridgeport Flyer diner, it was the home of A&W Root Beer and also a Dairy Queen. Five blocks up to the right on Cleveland Avenue was the home of Christina "Mom" Gehrig, mother of Yankee great Lou Gehrig. She lived there from 1948 until her death at Milford Hospital in 1954. Christina Gehrig was instrumental in organizing the Milford Little League and the Lou Gehrig Memorial Field on the current site of Jonathan Law High School. On June 29, 1952, she donated a plaque for the field house at Lou Gehrig Memorial Field. (Author's collection.)

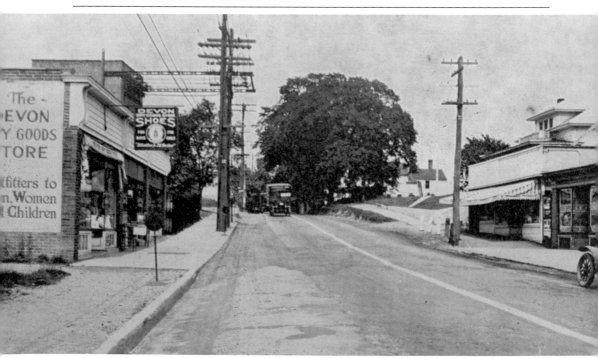

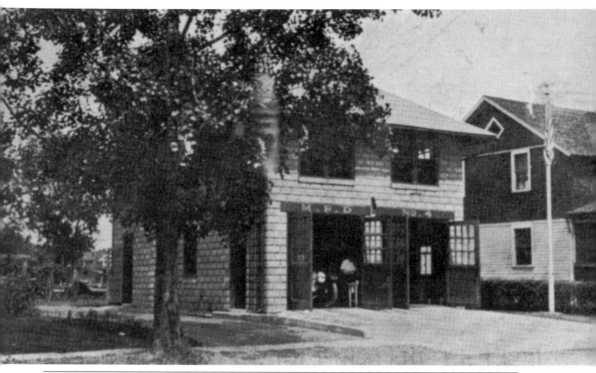

The Devon Hose Company No. 4, Inc., found at the top of Spring Street, was organized in 1908. This modern concrete fire station officially opened on December 9, 1918. On this same day, the town of Milford purchased a truck and chemical tank for the protection of Devon property. Until 1917, all volunteer fire companies operated independently with their own fire chiefs, and a house on Factory Lane was now the new home of Arctic Engine Company No. 1 and the headquarters for the newly organized fire department. This firehouse on Spring Street was empty for some time before the city sold it in an auction, and it has since been converted to a residential home. (Author's collection.)

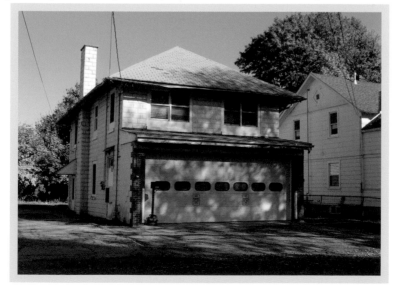

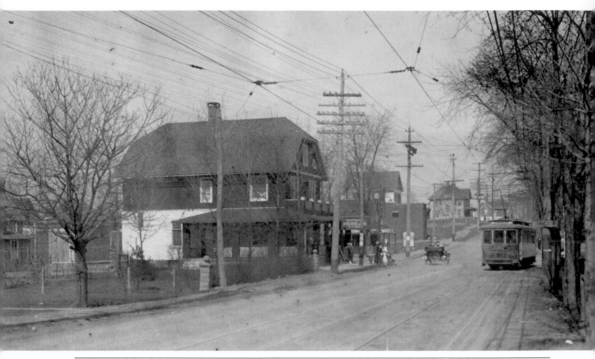

Looking east in Devon center, an early automobile is seen driving at its own risk on the opposite side of the road while a trolley is about to turn on Naugatuck Avenue on its way to Walnut Beach. The building to the left, which is still standing today, was A.W. Eades General Store, Ice Cream Parlor, and Saloon. In the 19th century, Devon was nicknamed the "Junction" because of the Naugatuck Railroad junction. After the railroad station was built, the area was called "Naugatuck Junction." In 1900, a developer purchased much of the land here and called this new homesite project, the "Devon Estates." On November 1, 1913, Naugatuck Junction was officially renamed Devon. (JS.)

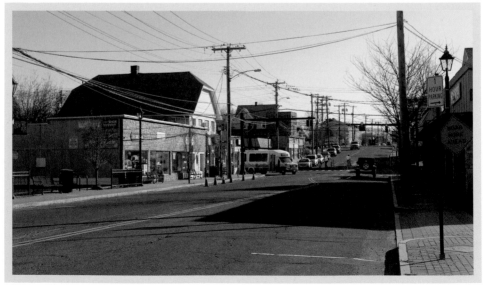

THE VILLAGE OF DEVON

A horse-drawn carriage is seen here riding south on Naugatuck Avenue, around 1910, in front of the two-story brick building to the right, Devon Grammar School before additions were added from 1919 to 1927. The first Devon fair was held behind the school in the 1930s. The building to the left was once the Devon Theater; when it was a theater, moviegoers could see a double feature, cartoon, Western serial, and the Pathé News for a dime. Minus the paved roads and sidewalks, this area looks similar to what it looked like 100 years ago. (JS.)

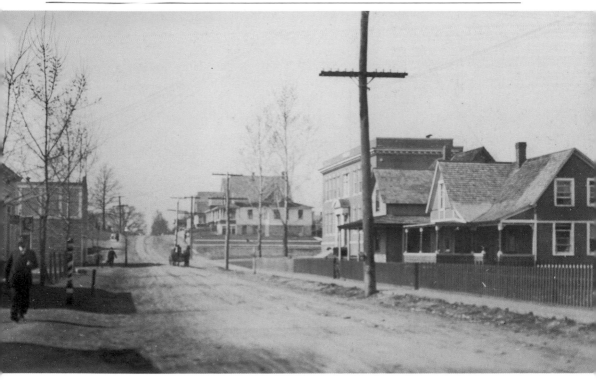

THE VILLAGE OF DEVON

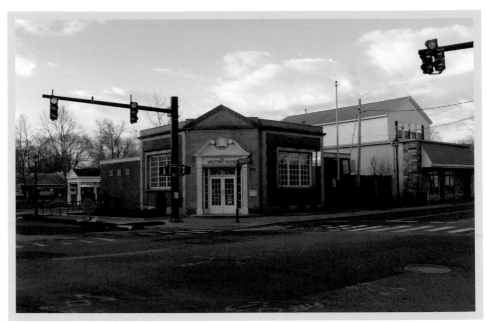

Here, a group of young men poses for a 1916 picture in front of this 12-room Gothic-style mansion. Built in the 1880s, this mansion was originally used as a boardinghouse. During the 1910s, real estate started to boom, building lots were sold at inflated prices, and Devon started to expand rapidly. New area residents were employed in Bridgeport factories, such as Winchester and Marlin firearms. Part of this mansion was moved to the right of the duckpin bowling alley only yards away. This corner is now anchored by the Milford Savings Bank with a row of retail shops to the right. (MK.)

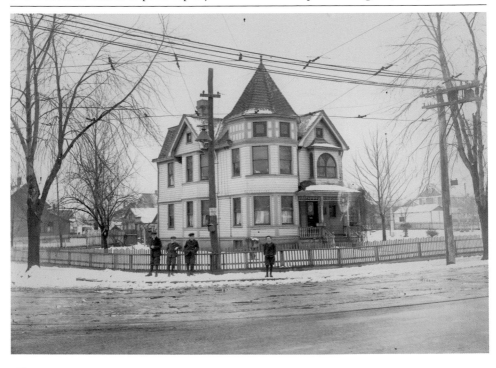

THE VILLAGE OF DEVON

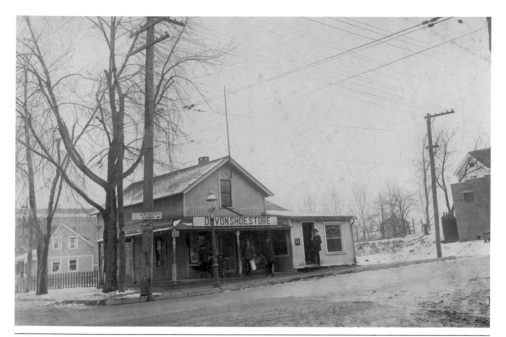

Behind the gas-powered lamp, some very well-dressed townsfolk stand at the northeast corner of Bridgeport and Naugatuck Avenues in front of the Devon Shoe Store and C.O. Mathews and Son Real Estate and Insurance office in 1916. To the right is part of the United Illuminating substation, and in the background to the left is Devon Grammar School. Note the advertisement on the telephone pole for the Rustic Inn, located in North Guilford, Connecticut. Some years later, this building was home to an antique store called the Tinker Box, run by Grace Lewis. Now, the gas lamp is replaced by a modern electric streetlight, and a modern brick building replaced the old wooden structure. (MK.)

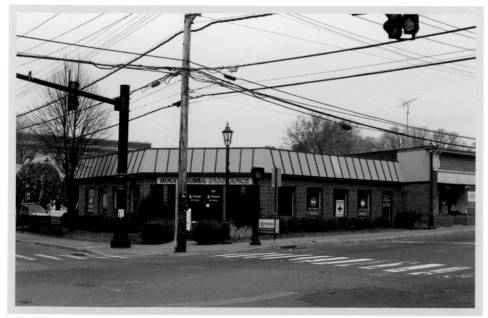

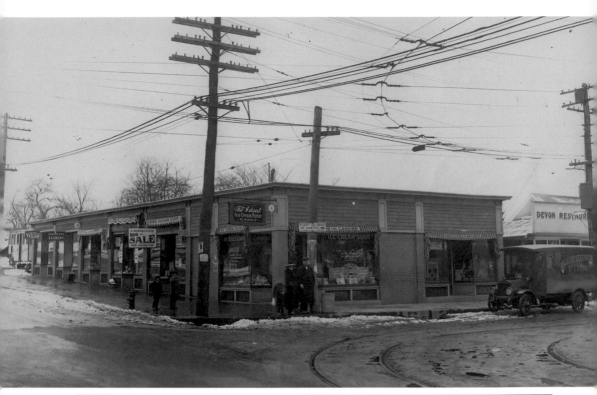

Nicknamed "Beard's Corner" in the heart of Devon, this busy corner in 1916 shows a scene that looks to be from *The Little Rascals*. The Ideal Ice Cream Parlor was this corner's anchor store. The building later housed Teddy Paul's and then the Butterfly Net, which was one of Milford's last-remaining penny candy and soda shops in the 1970s. This row of stores also included the Union Pacific Tea Company, Charlie Toy Laundry, and the Devon Restaurant. The Frisbie's Pie truck, shown here, was probably just making a delivery at the Devon Restaurant. The exterior of this building is almost without change today, 100 years later. (MK.)

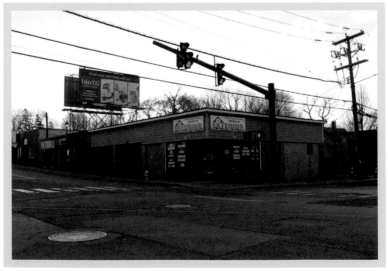

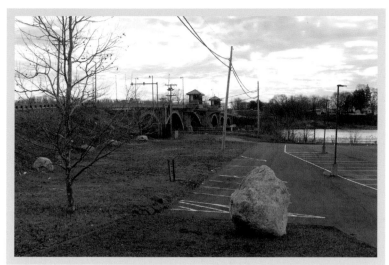

The only way to travel across the Housatonic River in 1648 was by ferry, which continued until 1802, when the first bridge was built here by the Stratford-Milford Bridge Company. It was named the Washington Bridge. After an ice flood swept the bridge away in 1806, a wooden bridge was built in 1807, followed by a third bridge built in 1872. A fourth bridge was opened to the public in 1894, and the first trolley crossed in 1897. In 1921, the fifth and current bridge on the left was open to the public. Up until the 1980s, kids, who were called "bridge rats," would often hang out under the bridge's arches, swimming and even jumping off the bridge. The concrete-and-stone foundations of the old bridge can still be seen today. (MK.)

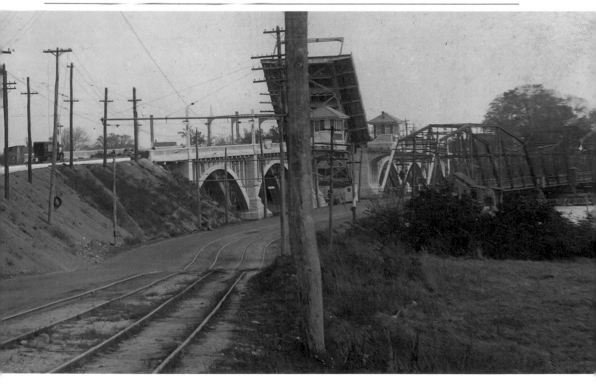

In 1900, the site of today's McDonald's was the property of Henry Miles Baldwin, who lived to be 106 years old. This photograph was taken seven years after the January 2, 1958, dedication of the new Connecticut Turnpike. Behind the photographer and out of view stands the Liberty Rock, formerly known as "Hog Rock" due to its shape. Chiseled on the side of the rock, one can still faintly see "LIBERTY 1776," which was carved by Peter Pierett Jr. during the Revolutionary War. It was said to have been a signal station, warning the locals of British war ships in the Long Island Sound. (MK.)

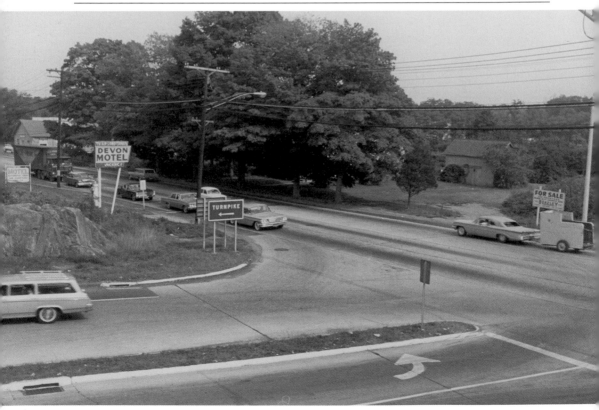

MYRTLE-WALNUT BEACH

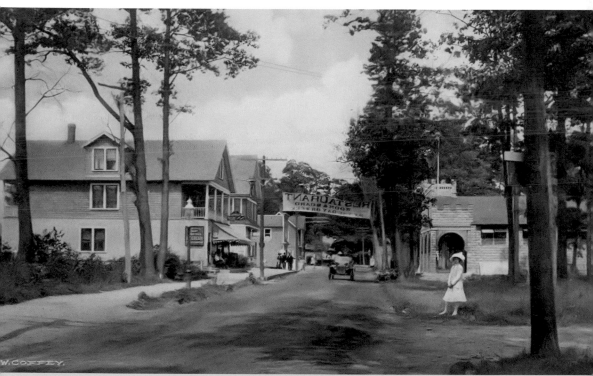

A smartly dressed young lady is standing here on the corner of Laurel Avenue and Broadway, as an open-air automobile drives west on Broadway at Walnut Beach in 1913. The castle-like building to the right was the Tower Theater, owned by Mr. and Mrs. Walter Gill, which could entertain an audience of 30 at 10¢ each. St. Gabriel's Church was later constructed on this corner at a cost of $47,000 and was dedicated on August 26, 1923. In 1945, the Tower Theater became St. Gabriel's new parish and recreation hall. (ERB.)

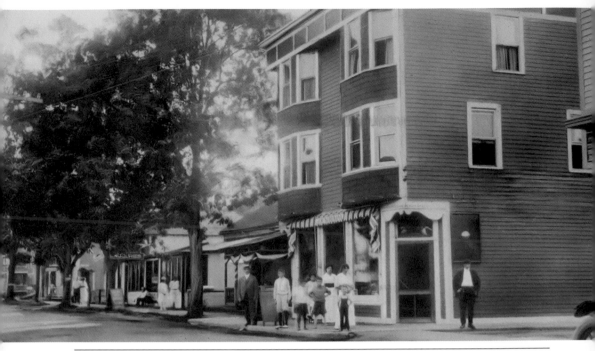

One young man in the front was able to hold a smile before the film could expose—not something many were able to do in the early years of photography. Because of all the hotel activity on the shoreline during these times, commerce was scattered all along Broadway in the Walnut-Wildemere Beach area. Among the shops located here on the corner of Broadway and Beach Avenue (now Botsford Avenue) are J.W. Schuman, a barbershop, and a grocery store. In January 1943, air-raid signals were installed at Walnut Beach, along with six other locations in Milford. By June of that same year, gasoline rationing and driving restrictions forced many of this area's businesses to close, never to open again. (ERB.)

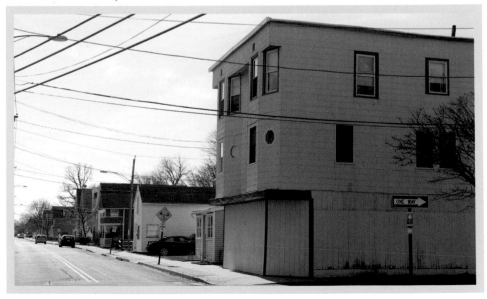

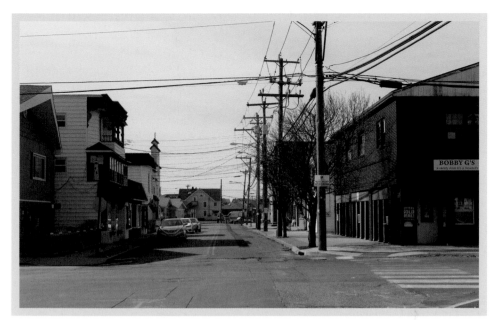

The heart and center of Walnut-Myrtle Beach was the intersection of Naugatuck Avenue and Broadway. This c. 1915 shot shows multiple forms of transportation. On the corner to the left was the Strand Theater, and behind that was the Soundview Hotel, next to a large oak tree grove. Davey Brothers was the general store then, and before that, it was Roach's General Store. At that time, the clerk would gather goods for the customer. Dairy products like butter and cheese were sold from tubs at 35¢ a pound. (NH.)

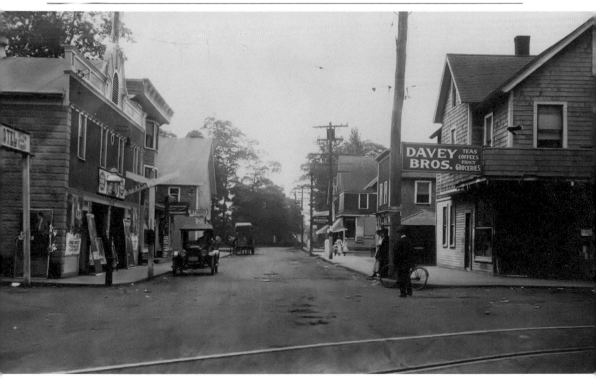

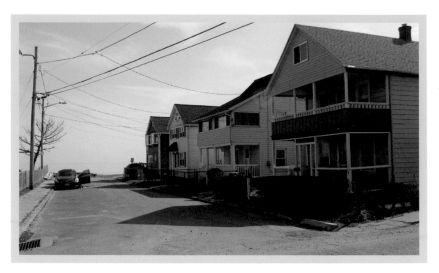

Homes like the ones seen here around 1912 on West Avenue (now Ann Street) were not winterized and were only used as summer cottages, for the most part. Over the years, as more sources of heat became available, front porches started to become enclosed and used for additional year-round living space. More than 100 years later, some of these homes can still be seen today. During the early 1900s, laws were put in place to make sure people were modest when it came to their swimming attire at the beach and pool. Men were not allowed to go shirtless, and women were to wear long, one-piece bathing suits. Presently, to the left of this scene is the popular waterfront restaurant Costa Azzurra, established and operated by the Faustini family since 1971. (Author's collection.)

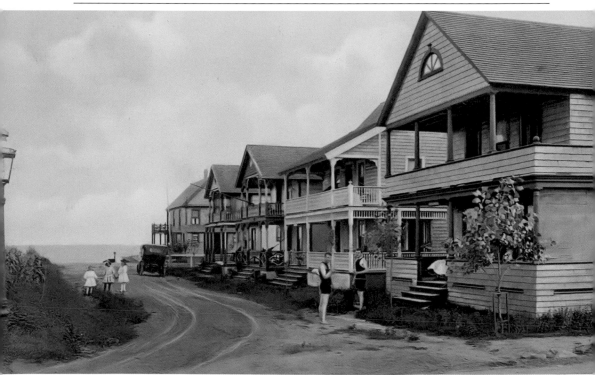

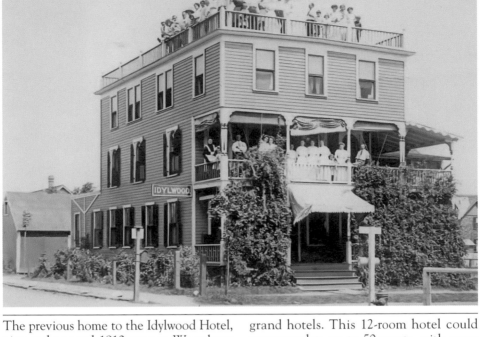

The previous home to the Idylwood Hotel, pictured around 1910, was at Waterbury Avenue and Broadway at Walnut Beach. In the first half of the 20th century, visitors by the thousands would come to this shoreline area by train and trolley to enjoy numerous attractions while staying at one of the area's grand hotels. This 12-room hotel could accommodate up to 50 guests, with more than 1,500 square feet of veranda surrounded by white railings on each floor, including the roof. Most, if not all, of these majestic hotels are gone now, replaced with large residential homes and condominiums.

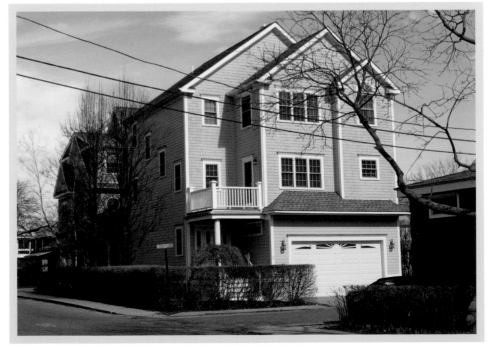

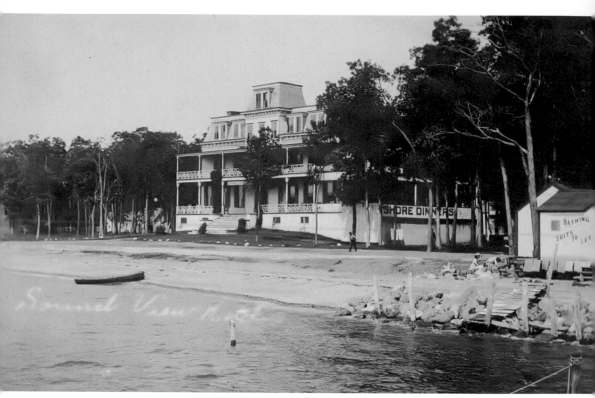

In 1912, four years after this photograph was taken, a weeklong stay at the Soundview Hotel would set a person back $5. The Soundview was purchased by the Stella family in 1934, after being vacant for a number of years. In 1941, the hotel was converted from a summer resort to a year-round, winterized hotel. In 1945, the Stella brothers, Geno and Kirdy, opened the famous Emerald Room nightclub and lounge. The nightclub attracted talented musicians, like Eddie Sulik; comedy acts; and burlesque shows. Don Rickles once performed here and was asked to leave after his comedy routine for being too insulting. The property is now home to the Island Sands luxury condominiums. (ERB.)

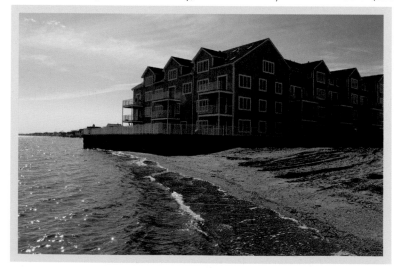

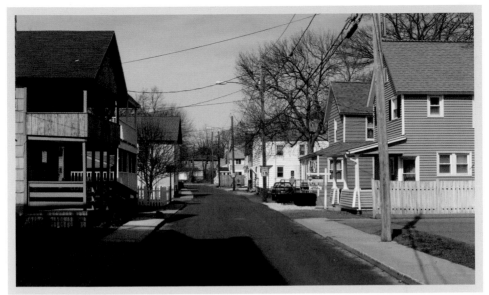

Beach Avenue (now Botsford Avenue) was yet another quaint street off the beach, lined with summer cottages, shown here around 1910. The development of these shoreline beaches began with the help of Mr. Haskins, also known as "the shore lot man"; Mr. James; Ernest Nettleton; and George B. Clark. The increase in shoreline property value ballooned Milford's grand list from $1.9 million in 1900 to $6.4 million in 1910. During this time, for $5 down and $5 a month, one could secure a lot to build and accept profits from rentals. In 1910, the American flag had 46 stars, including the recent addition of Oklahoma in 1907. (ERB.)

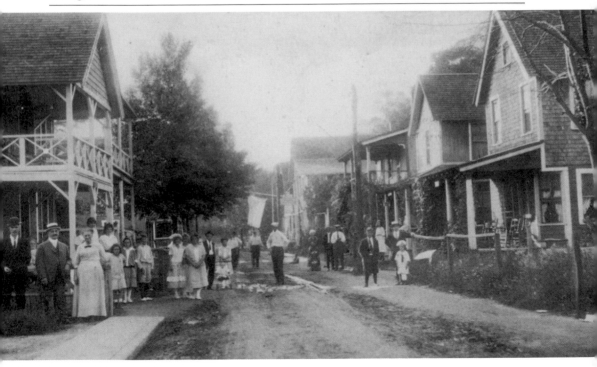

Pictured around 1910, a trolley is parked at the trolley station looking south toward Walnut Beach on Electric Avenue (now Naugatuck Avenue). Tinkham's Corner, known for its tasty summer treats like ice cream, popcorn, and roasted peanuts, is in the background on the corner of Broadway. Tinkham's was also popular for its postcards that depicted scenes of Milford. Many of these postcards can still be purchased today in antique stores around the country and are popular among collectors. This area was home to many popular businesses over the years, like Diamond Hardware, Arciuolo's Shoes, and the Pier III Pub. (Author's collection.)

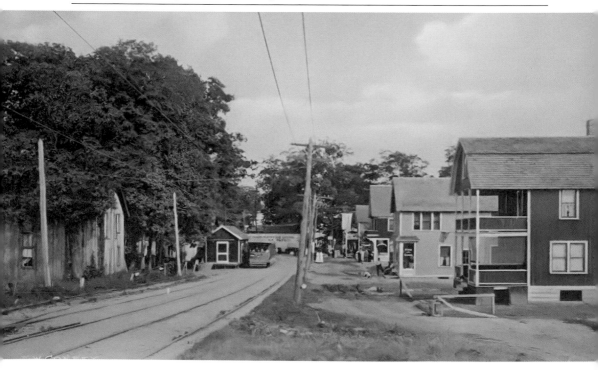

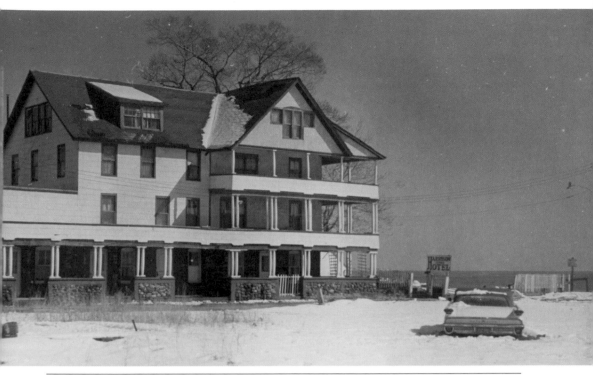

In 1918, the Islandview Hotel was Myrtle Beach's largest shorefront hotel, located at the end of Harrison Avenue and first owned by Sophia Fecker. Extending out behind the hotel was Fecker's Pier, a popular attraction among guests and local fishermen. The pier is long gone now, but one can still see its pilings jutting out from the beach. The Islandview was a popular destination among celebrities like Mae West, Gene Tunney, and Jack Dempsey. Some years later, the hotel was purchased by James Crossman, who renamed it the Harrison Arms Hotel, seen here just before it was razed on February 16, 1967, to make way for the area's redevelopment. (TC.)

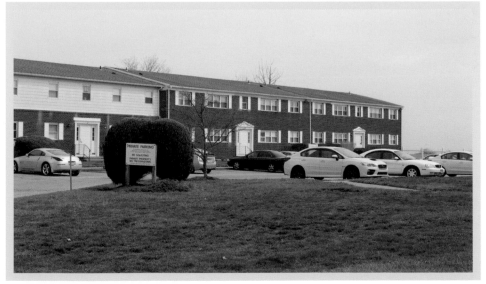

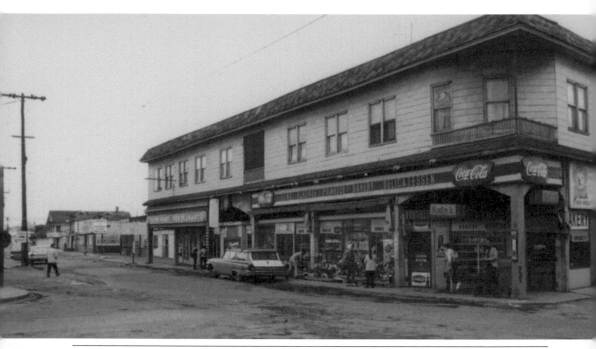

On the same corner where Tinkham's once stood in the early 1900s was Primrose's store, which stayed in business from 1920 to 1967. It is said that the owner, Ed Primrose, worked seven days a week for 47 years. Some other memorable establishments in this area were Fusco's Pizza parlor, Danny Smith's Black Sheep Restaurant and Bar, and the Wonder Bar and Grill. This area was also home to the Walnut Beach Amusement Park that opened in 1924 and, later, included a dance hall, merry-go-round, and a boxing ring. The Smith brothers took over the park in the 1950s, but in the 1960s, it became yet another victim to redevelopment. Primrose's store was razed on February 17, 1967. (ERB.)

MEMORY LANE

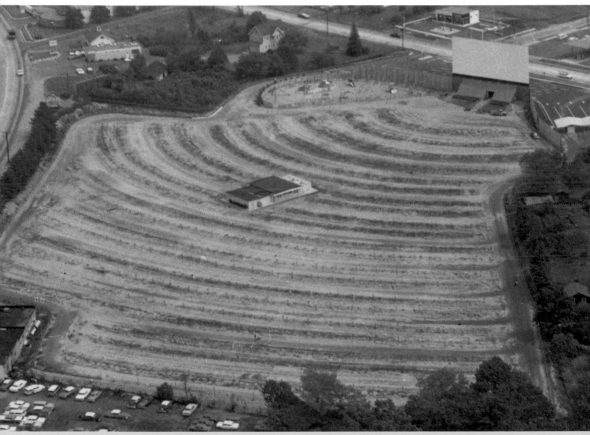

The Milford Drive-in Theater on Cherry Street opened to an eager crowd of movie fans on May 26, 1939, and was the first open-air theater in the state of Connecticut. By this time, there were only 18 drive-in theaters in the country. Decades later, the drive-in added an additional screen; they were called the Red and Blue screens. By that time, drive-in theaters across the country were struggling due to low attendance, and the Milford Drive-in was no exception. In February 1988, the Milford Drive-in Theater was demolished to make way for a new indoor, eight-screen Showcase Cinema. This theater has since been razed and is currently the home of Shop-Rite Supermarket. (TC.)

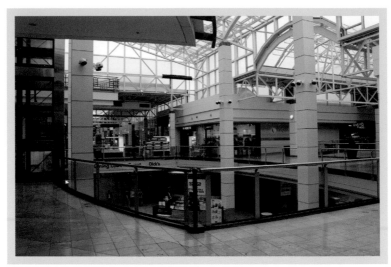

Long before the Connecticut Post Mall was built, this land was a seed lab testing ground. In 1954, the seed company sold its land to Sol Atlas for the construction of the Connecticut Post shopping center. There, in 1960, Stop and Shop supermarket became not only the first store to open its doors for business but also became the largest supermarket in Connecticut. The mall was enclosed in 1981. The lower-level tunnel that was used as delivery platforms became the first of two floors that now together make up over 150 retail shops, including the food court and a 15-screen theater. (TC.)

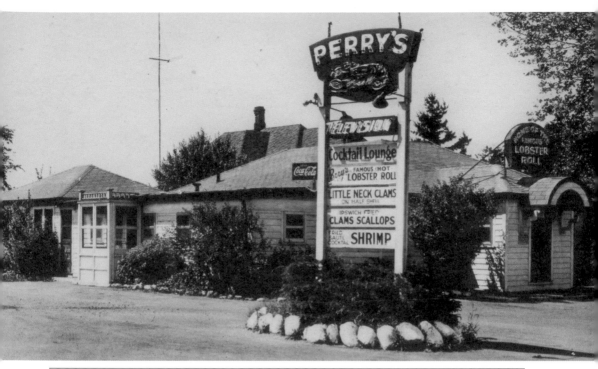

Perry's restaurant, once located at 667 Bridgeport Avenue, was not only a Milford landmark, but a national one as well. It is said that Perry's, owned by Harry Perry was home to the original lobster roll that started there sometime in the 1920s, when Harry Perry put hot lobster meat on a soft roll drenched in butter for one of his regular customers named Ted Hales. For close to 50 years, Perry's famous sign above the front door read, "Home of the famous lobster roll." This later became Armellino's Restaurant, which stayed in business for 28 years before the building was razed. It is now home to Chevrolet of Milford. (ERB.)

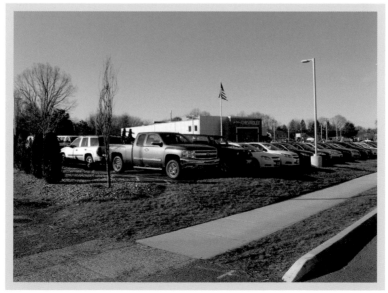

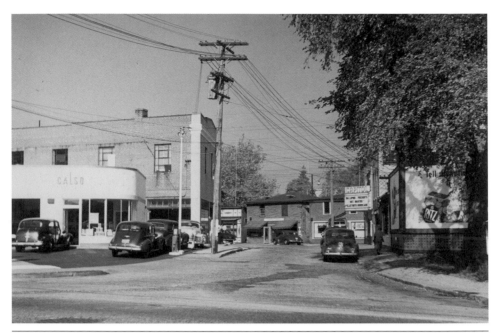

Probably the most popular of all of Milford's theaters was the Capitol Theater on Daniel Street in the center of town, shown here on the right in 1949. The theater, complete with a balcony, was built in 1920 by a Ukrainian immigrant from Hartford named Charles B. Nomejko. It set the scene for 80 years of memories, from the first moviegoers pulling up in Model T Fords until its last showing in 1998. Some more recent landmarks here were Jake's and the Office Café, known for its rowdy reputation. This area of Daniel Street is now home to the Stonebridge Restaurant, which originally started as a local seafood wholesaler called Milford Seafood. (TC.)

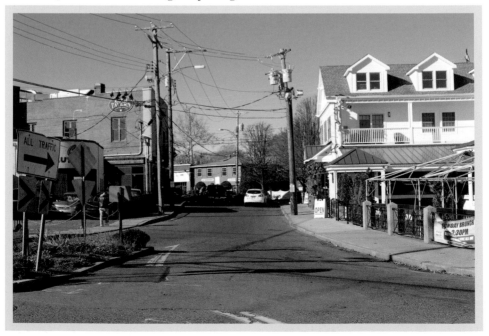

The Interdale Tavern, located on the corner of Naugatuck Avenue and Old Point Road, opened for business here around 1920. In 1943, Peter and Mabel Lasse purchased it from Mary Kennah. It was renamed the Maples, shown here in 1945, due to the abundance of maple trees that surrounded the restaurant at the time. Maples was not only a restaurant but also a banquet hall and nightclub, featuring comedy acts that included Bozo Kelly the clown. In 1958, the business was taken over by Tom Sullivan and renamed Lee Sullivan's. It was later purchased by Albert and Dario Faustini and renamed Aldario's and is still in existence today, after more than 50 years, operated by Chef Sante and his wife, Rose Mary Faustini. (LR.)

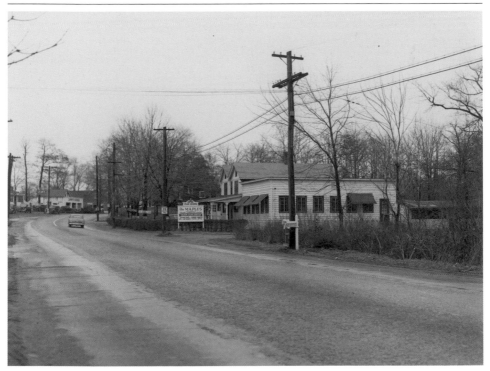

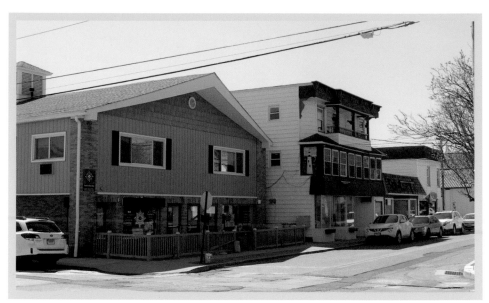

The Colonial, located at Broadway and Naugatuck Avenue, was the third movie theater to operate in the Myrtle-Walnut Beach area. It was run by Evelyn Smith and her husband before it was sold to Bob and Viola Elliano in the mid-1940s. For 15¢, one could watch favorites like Sheena, Queen of the Jungle, Captain Marvel, and Superman, while snacking on 5¢ popcorn and candy in the balcony. In the 1950s, the Colonial had a bingo night to help with struggling ticket sales, due to the rise of television. In 1958, the Colonial bingo hall was raided by the state police for operating an illegal gaming house. The theater closed down not too long after. (ERB.)

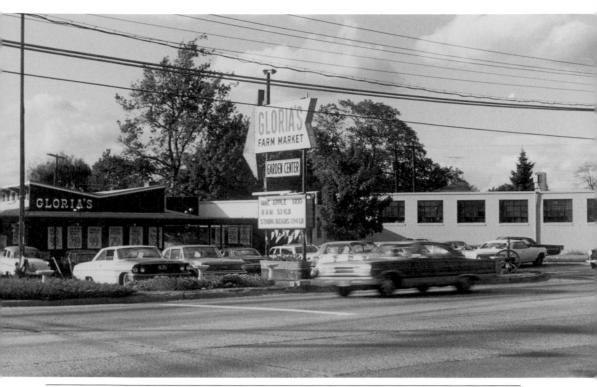

If there were a hall of fame for farm markets, Gloria's Farm Market would be in it. Anthony Gloria, whose original last name was DeGloria, emigrated from Italy through Ellis Island. Anthony Gloria started his business in New Haven, Connecticut, in the 1930s, pedaling fruits and vegetables from his cart. Anthony and his wife, Grace, had their grand opening of A. Gloria Farm Market on the Boston Post Road in 1949. Some years later, Gloria's Farm Market, a garden center, opened next door. The farm market had a highly successful 55 years in business until they officially closed in 2004. The voice of the famous Chrissy, the talking Christmas tree, was done by Lou Gloria's wife, Margaret Gloria. (SGS.)

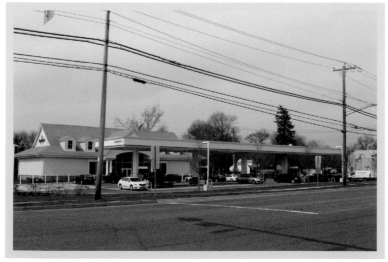

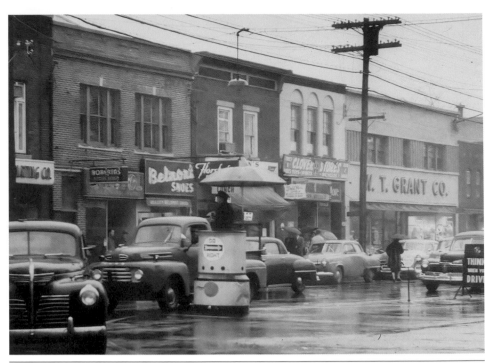

If a person lived in Milford from the 1950s through the 1970s when the police department was on River Street, then he or she would remember the police officer directing traffic from the middle of Broad Street between Factory Lane and River Street. Perched on a pedestal, wearing white gloves, and whistle blowing, the "cop in the bucket" was somewhat of a celebrity to the people of Milford, especially the kids who would sometime get a friendly wink and a smile. Eventually, when a streetlight and walk signals were installed here, the famous bucket became obsolete and was removed in the 1970s. Two police officers in town started working the night shift for the first time in the 1870s. (TC.)

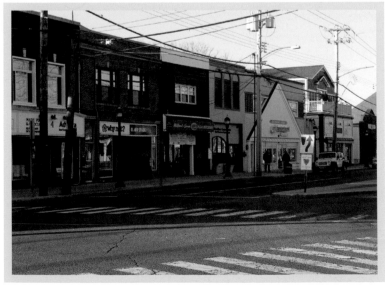

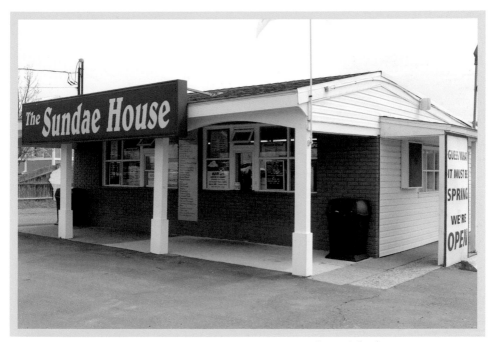

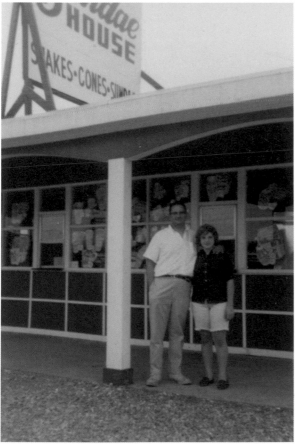

One of the longer-running businesses in Milford to date is the Sundae House on New Haven Avenue, shown here in 1965 with one of the owners, Blasé Picone, and his daughter Peggy. Blasé and his sister Angelina Simone started a fruit and vegetable stand here in 1957. After Carvel offered to buy the property in the early 1960s, Blasé and Angelina decided to open their own ice cream stand, calling it the Sundae House. Michael Petrucelli, a longtime friend, came up with the name and the design of the stand. Jim Simone, the son of Angelina and nephew of Blasé, has been running the Sundae House for the last 51 years. Though it closes during the winter, one of Milford's favorite pastimes reopens for business each year with a sign that says, "Guess what? It must be spring. We're open." (JS.)

Discover Thousands of Local History Books
Featuring Millions of Vintage Images

Arcadia Publishing, the leading local history publisher in the United States, is committed to making history accessible and meaningful through publishing books that celebrate and preserve the heritage of America's people and places.

Find more books like this at
www.arcadiapublishing.com

Search for your hometown history, your old stomping grounds, and even your favorite sports team.

Consistent with our mission to preserve history on a local level, this book was printed in South Carolina on American-made paper and manufactured entirely in the United States. Products carrying the accredited Forest Stewardship Council (FSC) label are printed on 100 percent FSC-certified paper.

MADE IN THE